WEST CORK
inspires

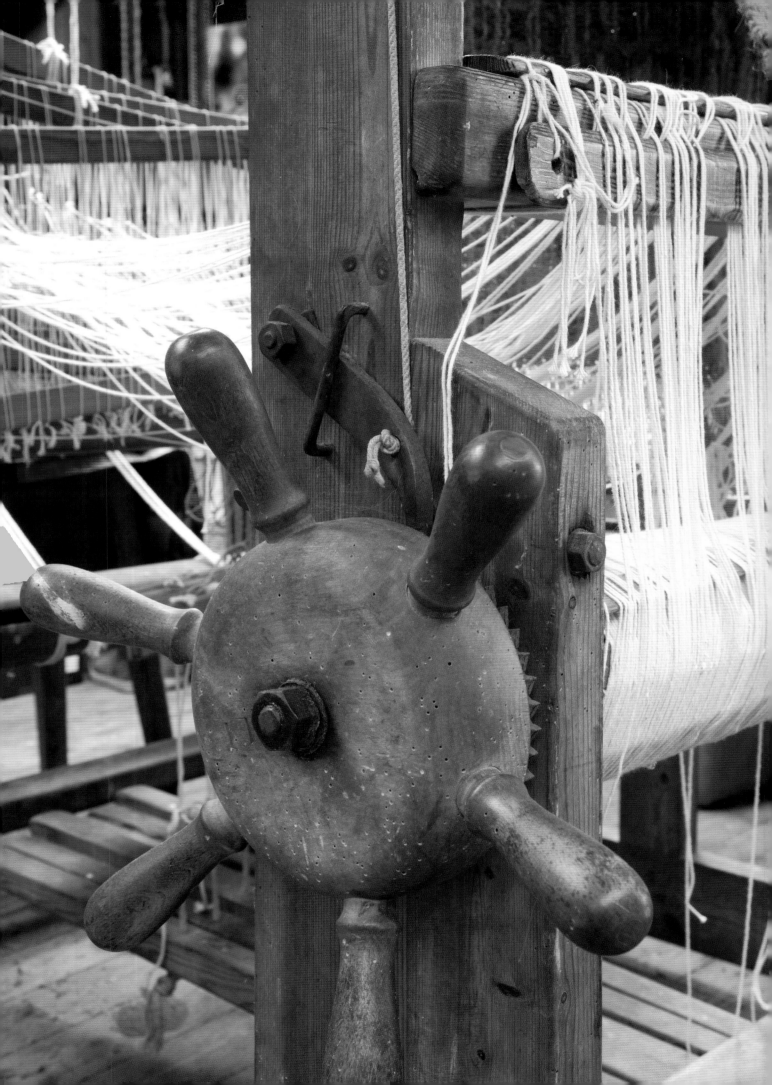

WEST CORK

inspires

Alison O[signature]

Alison Ospina

with photography by Roland Paschhoff

Stobart Davies

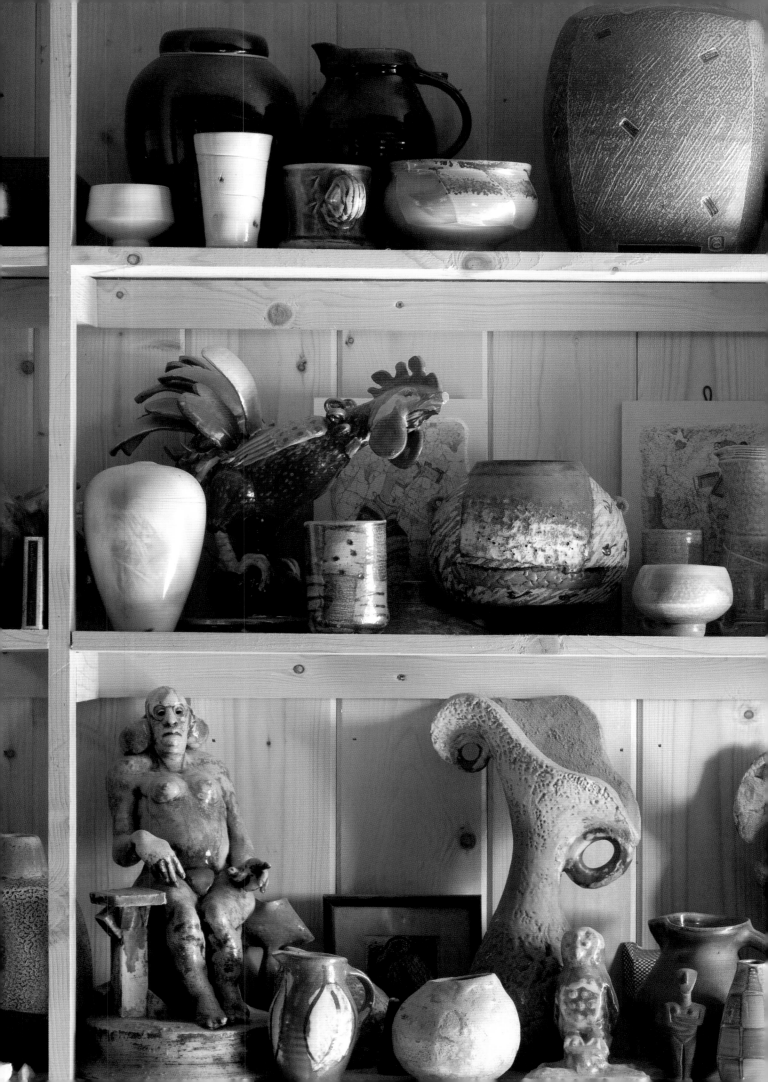

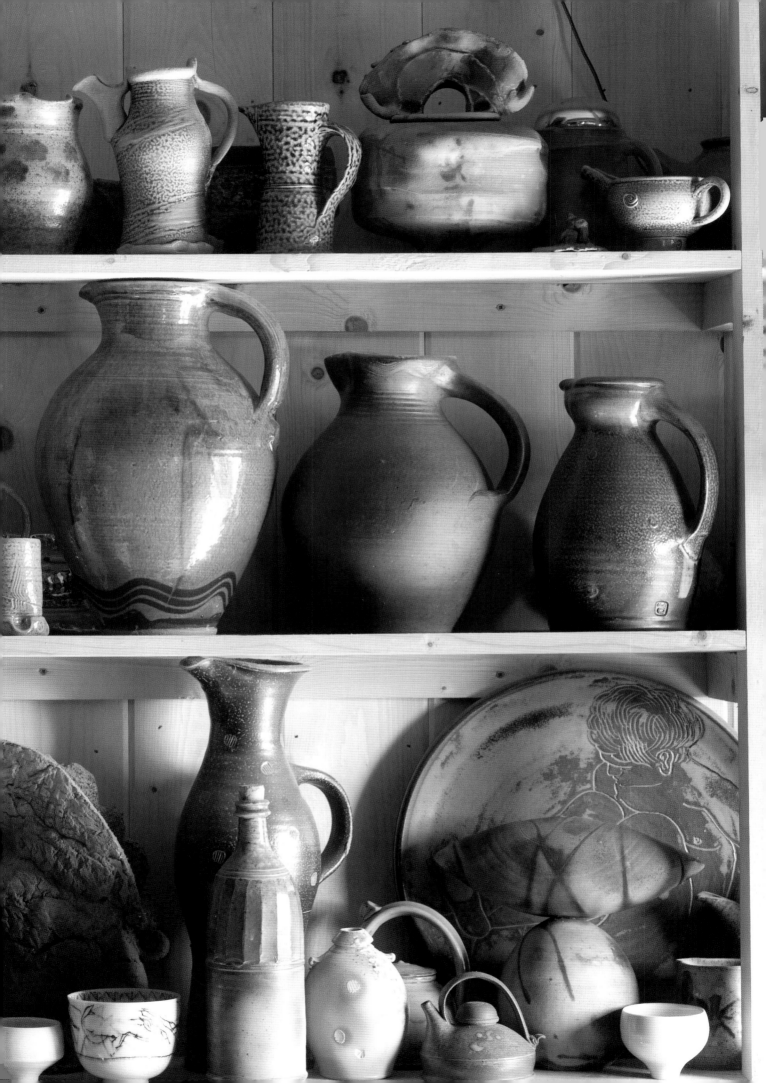

British Library Cataloguing in Publication Data.

A catalogue record of this book is available from the British Library.

ISBN 978-0-85442-196-1

Published 2011 by
Stobart Davies Limited
Stobart House, Pontyclerc,
Penybanc Road, Ammanford,
Carmarthenshire SA18 3HP, UK
www.stobartdavies.com

Graphic design by Zoe Turner and Stobart Davies Ltd
Photography by Roland Paschhoff

Cover photos taken by Roland Paschhoff
front cover: *Tree wave on the south coast of the Beara Peninsula*; insets (left to right): *Seán O'Conail, Cormac Boydell; Woven wall hanging, Barbara Harte; Large Oval Storage Basket, Norbert Platz; Necklace 'Flowers, Gert Besner; Porcelain Jug, Peter Wolstenholme*
back cover: *Dunmanus Point, Mizen peninsula*

The John Ruskin quotes are courtesy of Professor Stephen Wildman, Ruskin Research Centre, Lancaster University

We have been unable to trace the copyright holders of a small number of images in this book. We would be grateful to receive any information as to their identity so that we can acknowledge them in future print runs.

Printed by Akcent Media Ltd

To Ana, Eddy and Rosa for their help and encouragement while this book was taking shape and to José for his patience and amazing insights, which never cease to inspire me.

Page 2: *Barbara Harte's weaving loom, courtesy Ted Harte*
Pages 4 and 5: *Rossmore Pottery, Jim Turner and Etain Hickey's 'favourite pots' collection*
Page 7 (opposite): *'Emerging' spoon from Cherry, with bark, Ben Russell*
Page 8: *Bespoke steel knife blanks, Rory Conner workshop*

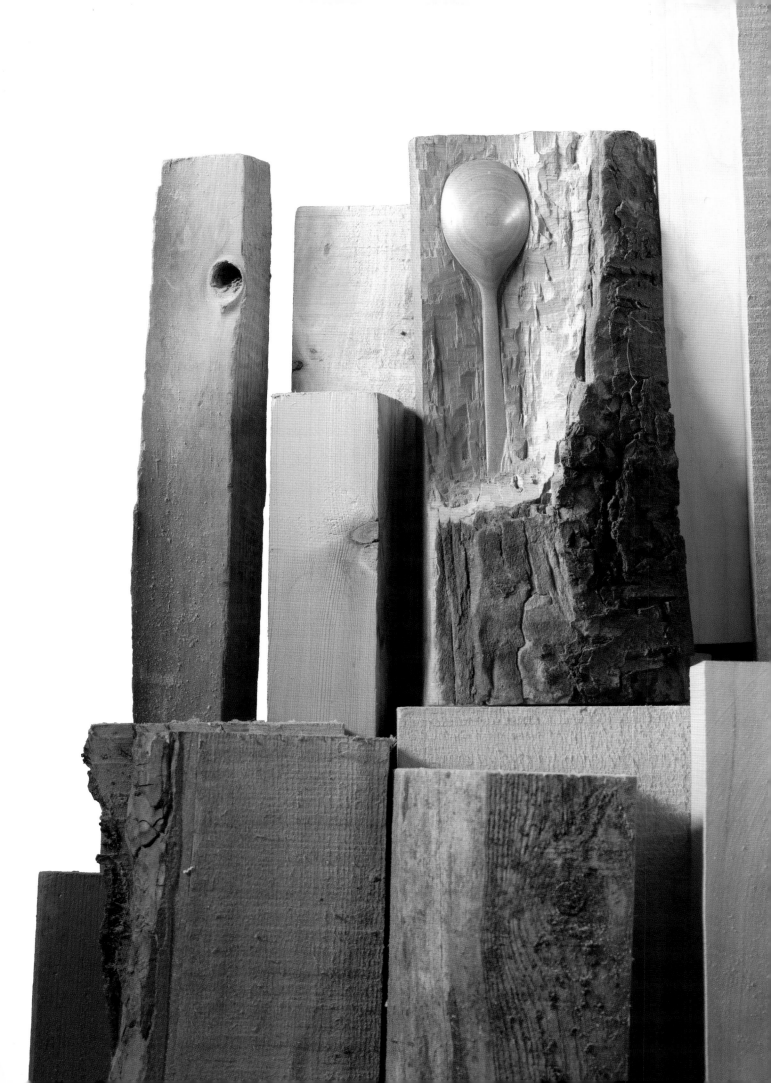

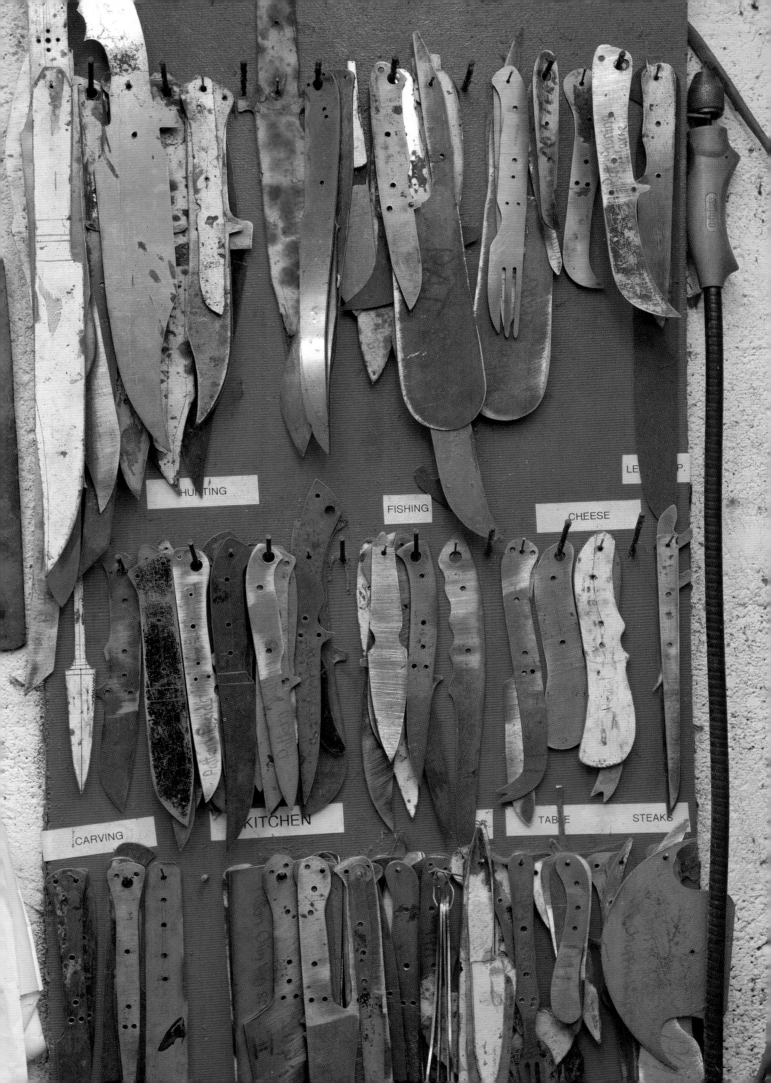

Contents

Introduction

What we think, or what we know, or what we believe is, in the end, of little consequence. The only thing of consequence is what we do. John Ruskin (The Future of England, 1869)

When I moved to West Cork in 1995 one of the first things I did was to join the brand new West Cork Craft and Design Guild. Over the next ten years I exhibited and sold my work with the group but only recently discovered that we were not the first, there had been a guild in West Cork before.

I found that many of the artists who had been involved in the older Cork Craftsman's Guild were still around and producing exceptional work. As I dug a little deeper I found that they had done many of the same things that we were doing, had thought the same thoughts and reached the same conclusions. Yet, here we were, building on their efforts without knowing the foundations had been laid by others, less than twenty years earlier.

Hidden down the leafy lanes of West Cork I have found artists whose work is of the highest calibre and should be considered of national importance. Due to limited time and resources, I have only been able to select twenty two artists to profile for this book. I know there are many more craftspeople whose work deserves recording. I have omitted to mention lace makers, boat builders, blacksmiths, candle makers, glass artists and leather workers all of whom have a rightful place in the history of West Cork. I have selected people working in a variety of media whose work

has had an impact on other craftspeople and has been influential in developing West Cork's reputation for excellence and originality.

West Cork's craftsmen and women share a fascination with the locality, its loneliness, the swell and sweep of its contours, the textures, colours and forms of nature that influence and inspire their work, albeit unconsciously. West Cork breathes a special atmosphere, a stillness and quality of light which appeals to our sense of beauty, mystery and wonder. Some say the landscape has a memory and a capacity to bind the living to the dead and to the unborn.

Certain themes have emerged whilst researching this book which may not at first seem obvious. Time and again, when discussing their own work, artists have echoed each others words and I have likewise made similar observations at every workshop and studio I visited. Craftspeople delight in the unpredictable nature of working with their chosen medium and many claim that their work is a collaboration between themselves and their materials while others feel it is a challenge or a struggle. They enjoy being self employed and having the freedom to choose when and how they work. Controlling the means of production is essential to the artisan's way of life, as is

carrying out every step of the creative process themselves. They are self motivated and self-disciplined and can produce the most amazing work from very little resources. Their studios are often no more than a shed, their tools basic but they dig deep inside themselves to produce wonderful art.

The craftspeople who made their homes in West Cork from the 1960s onwards converged on the region when a rare combination of circumstances allowed them to learn, prosper and thrive. In the 60s contemporary craft had not yet appeared in West Cork, there were no practitioners to compete with, property was cheap and the population was low. Crafts were about to become fashionable and West Cork was an unexploited beauty spot, accessible for visitors from Irish urban areas and from Europe.

I am indebted to those who have generously given their time and told me their stories and also to those who came before, of whom very little trace is left apart from a batik on a pub door or a treasured piece of jewellery given to a friend. They did not plan to leave a legacy nor did they imagine that simply because of their presence here and the work they produced, they had made a profound contribution to the West Cork aesthetic.

Alison Ospina
January 2011

Nora Golden batik on the door of Levis' pub

West Cork Inspires

art is valuable or otherwise only as it expresses the personality, activity, and living perception of a good and great human soul. John Ruskin (The Stones of Venice, vol. 3, 1853)

There is a special energy in the rugged West Cork landscape, which suffuses the artistic mind with inspiration and plays a key role in the creative process. Few countries in Europe offer such wild, empty landscapes such as those of Ireland's south west corner. In the 1960s and 70s, West Cork became home to an international creative community who fell in love with its clean, safe and creative environment, the beauty and magic of its landscapes and the joy of sharing ideas with like-minded people. This era saw the birth of the Campaign for Nuclear Disarmament (CND), the Women's Liberation movement, Earth-watch, Greenpeace and the Self Sufficiency movement, all groups which inspired many people to live closer to nature, to earn a living making and selling their own hand-made products whilst eschewing the excess trappings of modern consumer society.

In the early 1960s, Christa Reichel, a potter originally from Germany, moved to West Cork. She bought a house and set up the region's first studio pottery in Gurteenakilla, just a few miles outside of the village of Ballydehob. She later purchased with her partner, batik artist Nora Golden, a small shop complete with a cafe, in Ballydehob which they named *The Flower House*. Christa and Nora then invited friends, students,

previous page: *Merino fleece yarns*
right: *Christa Reichel and Nora Golden's shop, cira 1972, Ballydehob*

craftspeople and artists to come and stay and help out in the pottery. Word spread that West Cork was a beautiful, creative place waiting to be discovered and experienced craftspeople and others wanting to learn, started to arrive from all over Ireland and Europe. *The Flower House* was a success and became increasingly important as an outlet from which craftspeople could sell their work.

The craft community continued to expand and within a few years a significant number

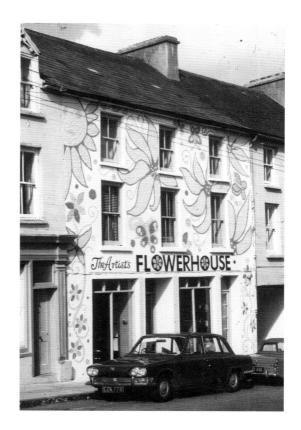

of artists and craftspeople had made their homes in West Cork. From within Ireland, people came mainly from Dublin and Cork. At least as many new arrivals came from the United Kingdom and Germany and others from Scandinavia, Holland, France and Belgium. They found houses to rent and buy at prices considerably lower than in their own countries. In addition, West Cork was considered, rightly or not, as one of the safest places to be in the case of either a nuclear attack or accident, due to its prevailing west winds and distance from any likely targets (fear of nuclear fallout was quite real both before and after the Cold War). Many people gravitated towards Ballydehob, the centre of the creative movement, while others looked further, from Bandon, just west of Cork, north to Macroom, and as far west as Castletownbere to the remote hills of Coomola near Bantry.

In the parlance of the day, this was a revolution as the social landscape of West Cork changed radically and irrevocably. The new arrivals brought new ways of thinking and new ways of living. During the first half of the century, West Cork had been an impoverished region offering few opportunities for employment or training. For decades, the younger generation had been moving away from the area hoping to find better prospects elsewhere. The newcomers brought a much needed vitality and colour to the area. They occupied houses which had stood empty for years and in many cases worked hard to bring them back up to a liveable standard. Even then, it was not uncommon for families to live for years without electricity and running water. It could be said that the new arrivals came west looking for a way of life that had been the norm in this region for generations, self building and repairing old houses, cultivating vegetables and keeping hens, sheep and goats.

Of fundamental importance was the acceptance and welcome extended to this influx of bohemian artists by the local population. Perhaps because of its turbulent history, the south west of Ireland has long been cosmopolitan. It has been visited, fought over and settled by soldiers, sailors, fisherman, mercenaries and various groups from mainland Europe and Scandinavia. Perhaps then, it comes naturally to the local population to accept incomers, despite their obvious differences.

A sense of community was important to the newcomers and gave a feeling that they were part of a wider movement. Social life revolved around the two very popular pubs in Ballydehob: *Gabes* which was run by

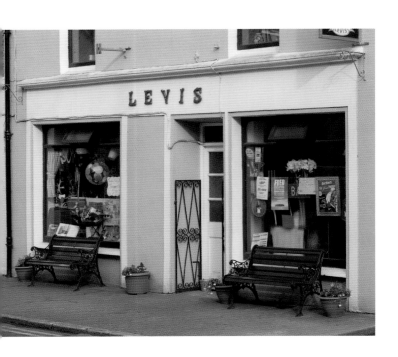

Levis Pub, Ballydehob

Gabe Hannon whose family came from Cape Clear island and *Levis* which is famously a pub, a shop and also owners' Nell and Julia's front room. Nell who is now 100 years old clearly remembers the groups of young people who regularly spent their evenings in the pub, drinking and chatting deep into the night. Displayed on the dresser and on the walls are ceramic pieces made by Christa Reichel and batiks by her partner Nora Golden.

Life was intensely social and people shared their resources, expertise and creative ideas. Live music was an important part of social life and many of the artists and craftspeople were also accomplished musicians. Nostalgic stories still abound of long evenings at *Gabes* where eminent musicians Christy Moore and Dónal Lunny played deep into the night just for the 'craic', of meetings held in each others houses, where everyone brought

Nell Levis in the pub she ran with her sister Julia for many years

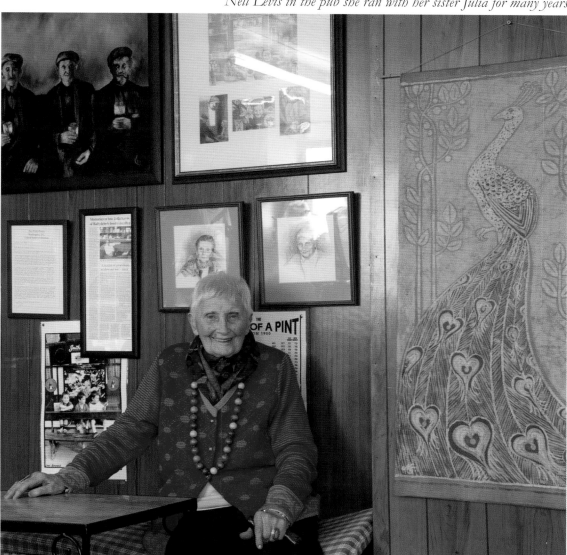

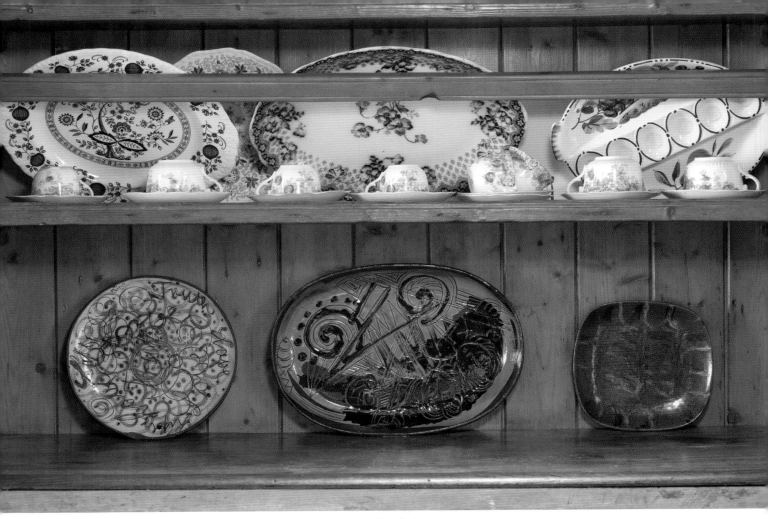

Christa Reichel plates, circa 1965, Levis' pub Ballydehob

something to drink or eat. 'No one was rich but we all helped each other. If you called in at a potter's studio you were offered dinner and bed for the night', remembers Etain Hickey. Little wonder that many look back on this as a wonderful way of life.

Although a large proportion of the craftspeople arriving were self taught and others subsequently learnt their craft skills in West Cork, many came with diplomas and degrees from Ireland, Germany and the United Kingdom. Of those who came from other parts of Ireland, several had attended the Crawford Art College in Cork or the National College of Art and Design in Dublin. They introduced a variety of contemporary crafts as well as breathing new life into some of the more traditional products. There was a sense that imaginations were set free and that West Cork was the place to forge a new, alternative way of life.

Many of the wider circle of people arriving did not have the resourcefulness to support themselves and their families in West Cork. Lack of transport posed serious challenges and often the houses they purchased or rented were in poor condition. During winter, the cold and damp would prove intolerable, especially for those with young children. During the spring and summer months, it was possible to imagine that life here was idyllic and laid back but reality hit when days grew short and the whole family could be isolated in a lonely house for days on end. Reading by candlelight and gathering around a turf fire for warmth ceases to feel like freedom when there is no other choice. Many came and stayed for two or three years but found life too difficult and so went home or moved on to another location.

The craftspeople adapted better than most as they were resourceful and able to support themselves at a time when handmade products were beginning to be popular,

even fashionable. Life was certainly hard and their lives frugal but it was possible to earn a living by making and selling craft. Several of the potters setting up studios during the 1970s including Noelle Verling, Pat Connor and Etain Hickey recalled that 'We just put a sign at the end of the lane and tourists would come and buy our stuff. In the summer we were so busy we could not keep the shelves stocked'.

The craft makers who arrived here during the last fifty years brought with them skills and design ideas gleaned from diverse sources. At least two of the craftspeople in that community, Brian Lalor and Bebhinn Marten had close family ties with the Arts and Crafts Movement of the early 1900s through their parents and grandparents. Whilst some had attended art colleges in Ireland, others came from countries which had different craft and design traditions. They brought something very valuable with them namely new skills and cultural aesthetic ideas from their own backgrounds and a use of materials never before seen in Ireland. They lived as part of a multi-cultural community sharing information and skills.

Many of the craftspeople did not limit themselves to working in one medium. It was not unusual to find potters who could paint, etch and print or jewellers who also worked with wood and enamel. The community was unique in that it blended West Cork tradition and inspiration with techniques and craft skills from all over Europe. Until then, crafts produced locally had a mainly functional purpose. Baskets were woven, cloaks were sewn and shoes were made. They may well have been good

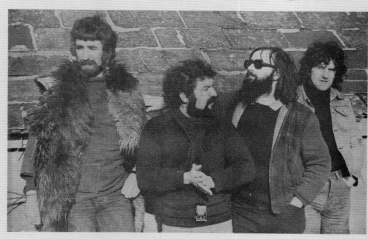

Original exhibition poster – courtesy Brian Lalor

quality products but design would have been informed by practical considerations rather than aesthetic ones. Those pioneers from the 1960s onwards started a movement which has grown and consolidated into a phenomenon of historical and cultural importance. Their legacy lives on in the huge number of craft producers now living and working in West Cork, producing work of an exceptional standard.

Basket Craft

workshop.

Craft History of West Cork

Now in order that people may be happy in their work, these three things are needed: They must be fit for it: They must not do too much of it: and they must have a sense of success in it. John Ruskin (Pre-Raphaelitism, 1851)

West Cork's landscapes have been shaped throughout history by backbreaking toil. The building of tombs and shrines, the enclosure of fields for livestock and the production of food have all been carried out by hand over several thousand years. The remains of ancient artefacts and copper mines on Mount Gabriel near Ballydehob indicate that this region was trading and producing metal artefacts during the Bronze Age. We can read the history of this region in its manmade landscape and through it we can glean some knowledge of its people. The craftsmen and women of today continue that tradition, everything that is made by hand has taken time, experience, knowledge and skill. The craftsman puts part of himself into everything he makes. In a world where the concepts of uniqueness and provenance are held cheap, West Cork remains a place apart, where artists continue to express themselves through their hands and their creative vision.

According to the earliest map of Ireland made by Greek geographer and astronomer Ptolemy, eastern Mediterranean seafarers had a detailed knowledge of the Irish coastline and especially of West Cork, demonstrating that they had been visiting and trading here for many years. Michael Carroll, in *A Bay of Destiny* states that the ancient Irish language contained Arabic numerals, Roman alphabetic numerals, with some additional Latin and Cycladic Greek (from Phoenician). It also had the same basic structure as early Greek. Tacitus, the eminent Roman historian wrote that 'the harbours of Ireland were better known to the seafarers of the Mediterranean than those of Britain'.

Michael Carroll goes on to suggest that the early inhabitants of Ireland could have come from outside Western Europe. Ancient Druidic rites strongly resemble those of the Sumerians (Persians) who had no temples but built stone altars on high hills and lit sacred fires during their ceremonial worship of the moon, sun and earth.

It is generally accepted by historians that as far back as 8,500 BC, Neolithic man or the Beaker folk (so called because they used clay to make vessels for cooking and eating) populated Ireland. However, primitive man had already been present in Europe for more than twenty-five thousand years. When he finally arrived in Ireland, whether by land (there was a land bridge in the north) or by boat, he would initially have stuck to the coastal areas for food, fresh water and safety.

previous page: *Basketry workshop – Norbert Platz*

The greater Bantry area and the Beara peninsula contain the greatest concentration of megalithic monuments in Western Europe. Similar monuments are also found in the Middle East, in the Mediterranean countries including Spain and Portugal as well as Brittany and the south coast of England, suggesting that a western migration of civilised people occurred over a very long period. This theory is born out by West Cork's many examples of burial grounds, standing stones and dolmens, the majority of which align with the sun, moon, stars and other natural phenomena.

It is logical to conclude that the leaps in knowledge, science and culture were brought into the country by visitors and settlers from outside. We know that Phoenician traders established outposts and settlements in areas where they traded on a regular basis and there is no reason to believe they did not do so here. Early references show that they were already trading with the 'peoples of the northern isles' for precious metals before 3,500 BC and could have established trading outposts along Ireland's southern coastline.

What is certain is that Ireland's cultural history is as rich and varied as the waves of people who have arrived on these shores, since ancient times. Whether by incursion, invasion or migration, incomers heading west came by boat from Italy, Spain, Germany, France and Scandinavia. These incursions brought with them a variety of racial types from the light boned, black haired Firbolgs to the tall, flaxen haired, blue eyed Norsemen or Vikings. Once they arrived, they usually established coastal strongholds and over time integrated with the existing population.

More recently, from the 17th century onwards British monarchs chose to plant entire communities into Munster, Leinster and Offaly. Many more Europeans followed, some seeking sanctuary, others looking for adventure and new opportunities. Records show the arrival of Portuguese Jews, Russians and Poles as well as French and Italian craftsmen, church decorators, music teachers, seamen, merchants and artisans.

An unbroken thread runs through centuries of creativity in West Cork. It can be seen in the profusion of dolmens and megalithic tombs of pre-history, the linen and wool industries, boat building and lace making, through to the contemporary crafts of the last fifty years and into the new millennium. Newcomers have brought with them new ideas for producing textiles, working metal, in the form of weapons and jewellery, the production of ceramics and decorative arts. This intermingling with the heady mix of earlier civilisations, has introduced a rich and brilliant medley of cultural aesthetic notions and ideas which makes the creative work in south west Ireland unique.

Cork Craftsman's Guild

I have always thought the 70s-90s was a Golden Era for the arts in West Cork – and Golden Eras don't come around too often. Gerald O'Brien, Skibbereen

Holiday homes began to appear in West Cork in the 1960s. Many of the regular visitors were attracted not only by the craft studios but also by the alternative life style that existed around Ballydehob and Schull in particular. According to Jim O'Donnell who, during the early 1970s gave up his job in the civil service and moved to Ballydehob to become a furniture maker, 'summers were good, there was a vibrant pub scene with live music, lots of socialising and talk about craft. We felt that we were doing something interesting here'. For the West Cork craftsperson, sales always increased during the summer months when there were plenty of tourists and visitors in the area. Schull had long been a favourite haunt for 'off duty' business men, politicians, famous writers and actors and their families. Art collectors were also attracted to the area by the profusion of studios in West Cork where they could visit the individual artists and purchase a range of interesting and exciting work. It is thanks to some of these perspicacious collectors that examples of the early work are still available to photograph or view today.

Previous attempts had been made by craftspeople to access the Cork city market with its larger population and busy shopping centre. Christa Reichel whose own shop the *Flower House* was trading well in Ballydehob, had organised a very successful exhibition at the Cork Arts Society in the Lavitts Quay Gallery in 1972. Building on the success of that show, Christa attempted to open a crafts shop in Shearer Street which unfortunately failed to thrive. However a certain momentum had developed and Gert and Lotte Vox along with Mary and Jim O'Donnell and Frank Sutton put together a plan for a shop that would run as a co-operative and be managed by the craftspeople themselves. In order for it to succeed they would need to have the commitment of sufficient craftspeople to keep the shop stocked with work of a suitably high standard on a sale or return basis.

These five people organised local meetings and canvassed crafts producers in the area to find a group that might be interested in forming a co-operative. A draft constitution was written and in April 1973 a group of fourteen people adopted the constitution and formed the Cork Craftsman's Guild. Frank Sutton (who went on to become the Chief Executive Officer of the Crafts Council of Ireland) was elected Chairman and weaver Mary O'Donnell became Secretary.

The founder members were: Pat and Adele Connor (ceramicists); Nora Golden (batik artist); Rene Hague (typographer); Barbara Harte (weaver); Mark and Pauline Hoare (candle makers); Patricia Howard (ceramicist); Bob and Leda May (ceramicists); Karin McCarthy (weaver); Jim

and Mary O'Donnell (furniture maker and weaver); Alexander Placzek (enamel artist); Brigitta Saflund (artist); John and Noelle Verling (ceramicists); Gert and Lotte Vox (enamel artists).

Among that original group were craftspeople from Ireland, Germany, Sweden, North America and the United Kingdom. They represented the international roots of the developing West Cork craft movement. Not only did they found the organisation but many of the members dedicated much of their time to running the Cork Craftsman's Guild over the next ten years. As membership grew, more people were added to the workforce and several of those who joined later also became fundamental to the management and day-to-day running of the Guild. The positive experience of working in a co-operative and involvement in the running of the shops, helped build confidence and develop organisational skills amongst the Guild's membership. All of the key people involved have built on their experience and continued to have productive creative lives and careers

The Cork Craftsman's Guild members rented a shop at 26 Paul Street in Cork which they moved into in August 1973. All repairs and fitting of the shop was carried out on a voluntary basis by the members. Small grants were given by West Cork County Development Team (five hundred pounds) and Ivernia (twenty pounds). AIB Bank was instrumental in giving generous loan facilities. On 8th October, 1973 the shop was officially opened by the government minister Peter Barry.

Archive brochure, circa 1979,
designed by Arthur Cole

CORK CRAFTSMANS GUILD

The centre for Irish Craftwork

POTTERY BATIK CANDLES CERAMICS CROCHET DRAWINGS
ENAMELLING FURNITURE GRAPHICS JEWELLERY KNITWEAR
PATCHWORK TOYS WEAVING WOODWORK

CORK CRAFTSMANS GUILD
was formed in 1973 to link many artists and craftsmen in the south of Ireland with the public and to open an exhibition centre for all crafts being produced.

CORK CRAFTSMANS GUILD
Savoy Centre St.Patrick's Street Cork · Tel. (021) 26053

The shop started life a little uncertainly with no particular strategic outlook except to foster crafts in Ireland. Their aim was to stock contemporary products as opposed to traditional folk craft. Their ethos was to accept work that showed a high standard of craftsmanship, without knowing if there was a market for that particular product. It has been commented in retrospect that to some extent there was a clash between that ethos and the Guild's commercial responsibilities.

In the early days there were not enough members to ensure the quantity and variety of work required to keep the shop ticking over. However membership and turnover gradually increased, Guild members found ways to promote the shop by advertising and by giving demonstrations of craft techniques on the premises. A small room at the back of the shop was converted into gallery space for exhibitions.

Decisions regarding the shop continued to be made by committee. Neatly-typed minutes are still extant which demonstrate the extent to which discussions lasted, detailing all comments and proposals and inviting suggestions from members. Communication between members had to be done by post as most people did not have telephones. (During the 70s telephones were expensive to use and there

Designs, Skibbereen

In December 1977, Eileen Byrne first opened the doors of her craft shop *Designs* in Main Street, Skibbereen. It was the first shop of its type to open in the town, selling contemporary crafts, most of which had been made in Ireland. For more than 30 years, *Designs* has been an important outlet for local craftspeople and customers alike and the shop has an established reputation for its variety of products and innovative window displays. From the outset, Eileen made a point of supporting new and emerging makers as well as stocking work from more traditional craft producers. Crafts-people who were setting up their studios in West Cork during the 70s and 80s appreciated her openness and willingness to try out new products.

In the early days Eileen, often accompanied by great friend and colleague Eileen O'Callaghan, would drive all over the country, visiting craftspeople and looking for new and interesting stock. The advent of the annual Irish trade event, Showcase, meant that by simply attending the show each January, they could find a wide variety of suitable products under one roof. 'Showcase has always been a great social event, we enjoy meeting up with people once a year and looking out for new products.'

The large number of excellent craft producers working in the region has given Eileen a great resource to select from. She believes the secret of her success is the combination of Irish made products with crafts from other countries. This mix gives the shop a sense of vibrancy and colour and means that her customers can always discover something new and exciting on the shelves.

The Craft Shop, Bantry

The Craft Shop in Glengarriff Road, Bantry was one of very few retail outlets operating in West Cork during the 1970s. Christine Nicholas who owns the shop has an excellent eye for new products. She is passionate about crafts and has long been a friend to makers who are just starting out, offering advice and encouragement when required. Most importantly, Chris would pay for stock when other outlets insisted on a sale or return arrangement. Many a craftsperson on the breadline has walked out of Chris's shop with a smile on their face and some money in their pocket. *The Craft Shop* remains one of the few craft outlets that exclusively stocks products that are made in Ireland. It has a strong local flavour with the best of West Cork crafts well represented in the form of handmade knives, green wood chairs, log baskets, handmade leather shoes, enamelled jewellery, handmade felt products and ceramic tableware. These products are combined with a wide range of carefully selected crafts from around the country.

was a three-year waiting list for installation). Therefore minutes, invitations to meetings and exhibitions had to be posted. Despite the difficulties, the Committee of the Cork Craftsman's Guild ran in an exceptionally democratic and efficient manner, as the remaining minutes show.

In 1976 Christine MacDonald became the manager of the *Cork Craftsman's Guild Shop*. She proved to be a very important asset, helping to develop the shop into a thriving business. By now, the Paul Street shop was becoming established and paying its way. The commission on sales stood at 35.7% on retail price and several Guild members were making a reasonable income from selling their work in the shop. The main problem it experienced was lack of space for displaying stock and therefore an inability to expand membership. Enquiries were being made on a regular basis from craftspeople all over the country wanting to sell their work through the Cork Craftsman's Guild Shop. As the popularity of the shop and the number of stockists increased, the Guild outgrew its premises in Paul Street.

The Cork Craftsman's Guild was approached by Robin Power, a property developer from West Cork, who offered them a larger shop premises in the Savoy Centre, on Cork's main shopping thoroughfare. The new premises addressed the issue of space and also placed the shop in a more commercially viable city centre location. After three more years of successful trading in the Savoy Centre, lack of space again became an issue and when Power Securities offered a premises in their new development in Dublin, members unanimously voted to expand again.

It is also worth looking at the political context of this movement. Justin Keating served as Minister for Industry and Commerce from 1973 until 1977. He took a great interest in the emerging contemporary crafts sector, recognising the possibilities for self-employment and job

creation in rural areas. He was also Chairman of the Board of Directors of the Crafts Council of Ireland during that time. Writer and Government minister Michael D Higgins wrote in tribute to Justin Keating after his death on 31st December, 2009, 'The beauty embedded in the ordinary, he felt, was revealed in the work of those who farmed and harvested and above all in the crafts where intuition and inherited indigenous wisdom combined with acquired learning to produce what was both functional and beautiful. As Chairman of the Crafts Council of Ireland, he sought to link art, craft, learning, wisdom and education'.

Guild members had voted to expand operations into Dublin and in 1981, with a loan of £20,000 from Bank of Ireland, a new craft outlet opened in the Powerscourt Townhouse development. At the same time the Cork shop was expanding again to develop extra display space for stock and an exhibition gallery. Very little grant funding or financial support was given to the Cork Craftsman's Guild. Repairs and improvements were often carried out by the members and bank loans were secured on the success and turnover of the shop which in 1981 reached £174,000.

left: *Lino print by Nora Golden, circa 1965*
above: *Promotional post card, drawing by Brian Lalor, circa 1976*

A report written in 1981 by Brian Lalor details the setting up of the two Cork Craftsman's Guild shops and lists the following key components to their success:

The quality of the arts and crafts being sold. The dedicated and generous use of members own time to attend to the daily problems of running the Guild.

The growing awareness of Irish people of the availability of functional and aesthetically pleasing domestic goods, clothing and decorative work being made in this country.

The Dublin shop ran into financial difficulties fairly quickly and for a variety of reasons. The high rent and staffing costs were important factors as was the Government's implementation of 35% VAT on craft products. Members of the voluntary committee who had been running the Cork shop for several years found the

The West Cork Arts Centre

The West Cork Arts Centre opened in 1985, providing a much needed focus for the exciting cultural activity developing in the region. A group of local people had decided to set up the centre as they recognised the value of the arts in people's lives and in the community. They worked tirelessly to find ways of supporting local artists and craftspeople and to provide opportunities for them to show and sell their work. A number of quality exhibitions were already taking place in various church halls and school facilities, generating a huge amount of public interest. The voluntary group felt that a dedicated facility would provide an important community resource for the region.

The WCAC developed a programme of annual exhibitions and events which attracted local buyers as well as collectors from Cork and Dublin. For many years, a member's exhibition took place in the summer where every member (professional artist or not) could put their craftwork, paintings and sculptures on display for one month. This was an exciting and innovative community event with both professional and amateur work on exhibition which encouraged huge audiences and animated discussion about the pieces on display.

Initially, the centre ran on a shoestring budget, staffed through employment schemes and generating its own income through sales from exhibitions and membership fees. It very quickly developed a reputation for exhibiting outstanding work, produced by artists and craftspeople living in West Cork. The centre's focus has widened over recent years to embrace contemporary visual arts from all over Ireland and beyond. Education is fundamental to its activities with a range of arts workshops, film screenings, seminars, talks and gallery tours organised throughout the year. The WCAC has provided an important community resource for the arts and art education and is looking forward to consolidating and expanding that role with a new, purpose-built facility in Skibbereen town centre.

additional workload too onerous. These members had given their time, enthusiasm and energy over a long period and at this stage were reaching their limit. Membership applications, from craftspeople wanting to join, were arriving at a level of twelve per month. The selection committee, whose job was considered of paramount importance to the reputation of the Guild shops, not only selected work but also undertook to send a detailed written report for each submission to craftspeople whose work was rejected for any reason. As the workload increased so did the financial pressures and eventually the Dublin shop could not pay its bills and had to close. As both Cork Craftsman's Guild shops shared the same bank account, it proved impossible to maintain either shop.

Several factors seem to have contributed to the demise of the Cork Craftsman's Guild and a variety of explanations have been suggested by those people who were involved at the time. Some believe that both shops could have continued, as a rent reduction had been negotiated on the Dublin shop but that lack of confidence led to withdrawal of 'sale or return' stock, when it was most needed. Others feel that neither shop could have survived the recession of the 1980s nor was enough of the stock selling quickly enough. It has been suggested that a solid, committed group whose work did sell were, to some extent, carrying the other producers. The co-operative system was indeed quite cumbersome with decisions being made at meetings where discussions could last well into the night.

After the two shops had closed, the manager of the Cork shop, Christine MacDonald opened her own retail outlet and continued to sell high quality crafts in Cork right up until her death in the 1990s. Whilst running the *Cork Craftsman's Guild* shop she had developed good relations with both craft suppliers and customers. As her own shop was not a co-operative, she was free to select stock that she knew would sell quickly. Furthermore, she purchased the stock directly from the craft producers instead of taking it on a sale or return basis. Christine MacDonald is legend amongst Cork craft producers and stories of her shop are still told to newcomers to the craft scene.

To give some context to this venture, albeit in Dublin, a similar very successful attempt had been made to run a co-operative craft shop, principally established for suppliers in 1930 by Muriel Gahan. *The Country Shop* on St. Stephens Green, traded for forty eight years as a registered co-operative. Its purpose was to provide an outlet from which products made by rural craftspeople could be sold for a fair price. Muriel Gahan recognised the importance of design, innovation and standards of craftsmanship and in 1946 she wrote 'it is only by concentrating on quality and originality that our products can hope to find a place in the world market'. *The Country Shop* also ran a restaurant and exhibition gallery, and the success of the restaurant was important to the viability of the whole venture and helped to keep the shop afloat in the early days. It was a non-profit organisation that redistributed money to its suppliers. It was dedicated to generating much needed income for country craftspeople and 'making rural Ireland a better place for women'.

The Cork Craftsman's Guild played a vital role in the development of the craft sector

in Ireland. It was held in high regard by those State agencies which offered financial support to small rural businesses. As Chairman of the Guild, Jim O'Donnell would often receive enquiries from various agencies seeking confirmation that particular craftspeople who had applied for funding were in fact producing high quality work. In other words being a member of the Guild was considered to be a benchmark for quality. By setting the standard bar high, the Guild demonstrated their understanding that quality of workmanship and innovation were important factors in the production and marketing of crafts.

Similarities can be drawn between the Arts and Crafts Movement which started in the late 1800s and the situation that developed in West Cork during the 1960s. From around 1850 and into the early years of the 20th century the Arts and Crafts movement fought to gain recognition for the intrinsic beauty of well made, well designed items that were produced by hand. The movement was in some ways a reaction against increasing mechanisation and mass production. Industrial processes were churning out thousands of identical household items which were convenient and cheap but also unexciting. No longer could the touch of the human hand be seen in our everyday household objects.

During the 1960s and 70s people were re-discovering the pleasure and satisfaction of making things by hand and people were interested in buying them. Craftspeople were producing work that not only introduced new materials and techniques, but also introduced the concept of design to everyday objects. Traditional cups and saucers were replaced by mugs which could be squat or tall, surface decorated with a variety of glazes or odd a-symmetrical shapes, special because they were made by somebody you knew. The kitchen tables of West Cork were now host to oven-to-tableware teapots and plates that were characteristic of a particular maker. Visitors to your house would immediately recognise the local potter who had made your dinner service, whether it was stoneware or earthenware and what kind of glaze was used. The Cork Craftsman's Guild stimulated a growing awareness and appreciation of craftsmanship in the south west of Ireland and developed an informed following of buyers and collectors. Today West Cork remains one of the most important areas in the country for arts and crafts production; its name is synonymous with innovation and creativity.

Society of Cork Potters

Making pottery should not be like climbing a mountain, it should be more like walking down a hill in a pleasant breeze. Hamada Shoji

Potters and ceramic artists have been particularly well represented in West Cork over the last 50 years. In 1980, potters made up a large proportion of the membership of the Cork Craftsman's Guild and were very active in the management and running of the co-operative. Involvement in the Cork Craftsman's Guild had helped build confidence and develop organisational skills amongst its membership. It was then a relatively simple progression for the group to organise a nationwide get-togethers for potters to include lectures (from Jill Crowley and James Mellon) demonstrations, an exhibition and a general sharing of ideas in West Cork.

Les Reed, Society of Cork Potters – he became CEO of Crafts Council of Ireland

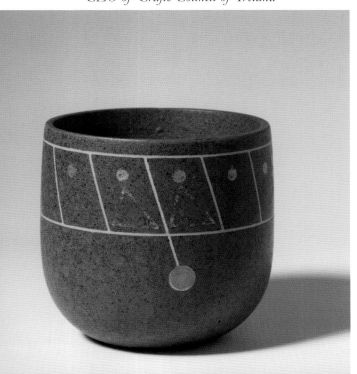

Jane and Robin Forrester, Peter and Fran Wolstenholme, and Inge and Les Reed were the potters who conceived the idea and subsequently invited every potter they could find in Northern Ireland and the Republic to gather in Bandon for the first such event to take place in Ireland. One hundred potters attended and the weekend was considered a tremendous success. The Cork potters were inspired to continue networking and sharing ideas with each other although they accepted it would be difficult to maintain contact with 100 members nationwide. It was decided to create a group for Cork County, restricting membership to professional potters and sculptors.

In 1981, The Society of Cork Potters became a formal organisation with representation on the Crafts Council of Ireland Board. The group ran regular events which included weekend workshops with invited experts who gave lectures and showed slides of their work. These events had a strong social element and while potters were keen to share their own ideas and expertise, it often took place at shared barbecues and raku firings as outdoor bonfires were required for both activities. A simple map was produced showing approximately where and how to find the pottery studios mostly hidden away on the back roads of Cork County. The map was

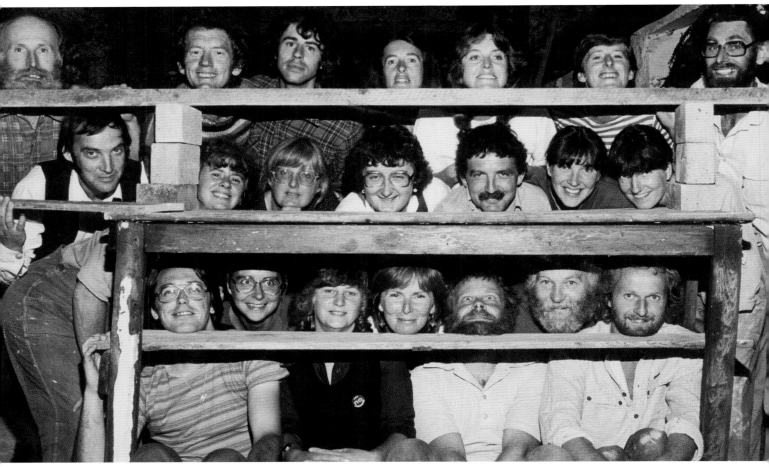

Society of Cork Potters members, 1982 – (left to right) top row: *Robin Forrester, Cormac Boydell, Mark Browning, Patty Mullaney, Lynne Wright, Helen O'Driscoll, Cameron Ryle* Middle row: *Peter Wolstenholme, Jane Forrester, Barbara Keay, Patricia Casey, Pat Connor, Etain Hickey, Siobahn O'Malley* bottom row: *Leslie Reed, Gabi Beuchert, Fran Wolstenholme, Irene Ryle, Jim Turner, Tom Mullaney, Ian Wright*

distributed by the Crawford Gallery and the Cork Craftsmen's Guild Shop in Cork as well as the West Cork Arts Centre in Skibbereen.

The potters who became members of the group, ranged from makers of functional tableware and plant pots to ceramic artists like Pat Connor, Ian and Lynn Wright and Cormac Boydell. In many cases, the potters who designed and made ranges of tableware to bring in a regular income, worked hard to develop their more

individual artistic work in the few hours left when they were not throwing, decorating, glazing or firing the kiln. The Cork Potters Society exhibitions were organised to provide a showcase for its members' more adventurous and innovative work.

The society met regularly at *Bandon Pottery* because Jane and Robin Forrester had more space than anyone else and they were in an accessible part of West Cork. In 1982 the Society of Cork Potters co-operated with

Lutz Kiel of *Carrigaline Pottery* to organise a ten-day symposium with invited international ceramic artists running workshops in raku, salt glaze, architectural ceramics, surface decoration and sculpture. This event attracted world-wide attention from ceramic artists and academics, as did the exhibition running alongside the workshops and offering substantial prizes.

Building on the success of that event, in 1983 a programme of workshops to celebrate the World Crafts Council Annual Congress taking place in Ireland were organised in West Cork. Pottery demonstrations, workshops and exhibitions took place over a ten day period at studios in Bandon, Courtmacsherry and Schull, with visiting potters from Hungary, France, Germany and the UK. Small grants were often available from the Crafts Council of Ireland and the IDA to pay for international experts to visit Ireland and give talks and demonstrations. However, most events were run on a very low budget. Accommodation and meals were often provided by the potters in their own homes and materials were paid for by the participants.

In addition to the major events, the Society continued to organise and host annual exhibitions at the Crawford Gallery. In 1986 the exhibition was shared with an invited group representing the Association of Californian Ceramic Artists. The following year, Bob and Jenny Kizziar travelled from San Francisco to deliver a week-long workshop at Lettercollum House near Timoleague. This workshop was open to ceramic artists from all over the country and was attended by around 50 participants.

Archive exhibition invitation 1979, Jane Forrester

Many of the founding members came from England and may have been inspired to form an association, through their awareness of the Craftsman Potters Association of Great Britain. The CPA was set up to organise exhibitions, promote the work of studio potters and help them to sell their work. Jim Turner's father, Roger Turner had been instrumental in setting up the CPA in the late 1950s.

The society was run by a small, local group of potters who were committed to the idea of sharing skills and learning new ceramic techniques. They were also a very social group and through their activities, developed a sense of solidarity and mutual support. The Society of Cork Potters has never formally closed down. When the founder members decided to step back and take a less active role in the organisation, activity slowly petered out and new members did not come forward to take up the mantle. Many of the founder members are at the point of retiring and are still producing exceptional one-off pieces and special commissions. Many collectors of their work look forward to the possibility they might come together for one more retrospective exhibition.

Sheep in winterly Coolenlemane Valley

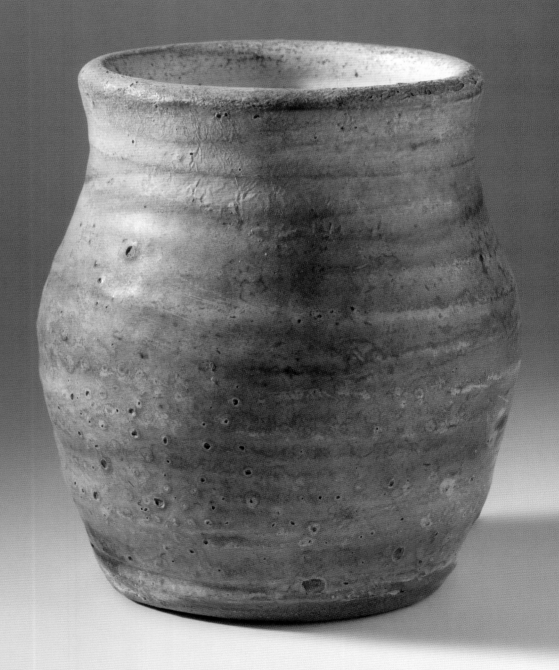

Earthenware pot with tin glaze, circa 1969

Christa Reichel (1932-2009)
Potter

Christa Reichel was an artist first and foremost. She loved, studied, and made art throughout her adult life. A complex woman, not given to introspection, she lived from a large and generous love of life and of people. Her art was an intrinsic part of her everyday world of work and relationships. She trained as a sculptor at The City and Guilds in London in the late 1950s. Craftwork was a natural and pragmatic extension of her sculptural practice. Clay for her was a living breathing entity, malleable, pliable and enduring. She called her little parcels of clay, which she placed on shelves around her studio, 'her babies'. She would pat them, turn them over, unwrap and re-wrap them in their plastic coats.

Christa and her husband Frank had no children. Their short, tempestuous marriage was one of restless creative energy – a survival tryst. When he left her, penniless, in a damp and derelict farmhouse in West Cork she had to survive alone. Christa found enormous warmth and kindness from her neighbours in this post famine, pastoral, subsistence society into which she had stumbled unwittingly. Anonymous food parcels were set on her doorstep – presents of chickens and potatoes were offered and gratefully accepted by her.

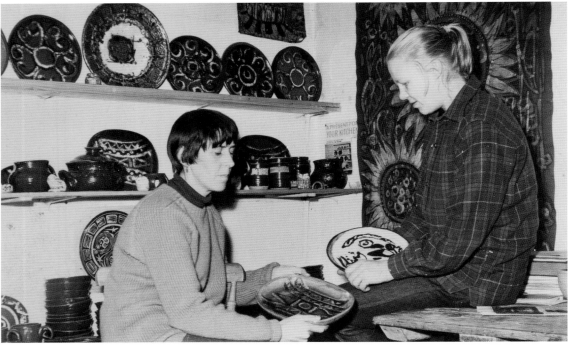

Nora Golden (left) and Christa Reichel, late 60s

When the wheel of fortune did really begin to turn for Christa her greatest champions and supporters in those heady early days of West Cork pottery were Nell and Julia Levis, publicans and shopkeepers in Ballydehob. Their earliest vivid memory of meeting Christa, recounted years later, was her mid-morning appearance in the doorway of their premises. 'She stood there, this six-foot-tall woman in Wellingtons and a long black mac, asking us if we would buy the two limp chickens she had firmly grasped in each hand', recalled Julia.

The word of Christa's presence in the district had no doubt preceded her appearance in their bar. Their morning meeting was the beginning of a firm friendship which never wavered throughout the vibrant and passionate years of Ballydehob Artists Ltd. Brick by brick Christa and Frank laid the foundations of West Cork pottery. Their farmhouse was purchased for £200 in 1964, from Jimmy Ducloe, a shy bachelor farmer who worked his acres under the blue ridges of Mount Gabriel. The farmhouse, outbuildings, and one acre of field were in the townland of Gurteenakilla (the church in the little field in Irish).

It was Frank who had discovered West Cork, on an excursion from Strangford, where he and Christa first lived in Ireland. However, Northern Ireland, although scenically beautiful, was heavily Anglicised and rigidly Protestant and did not engage their imaginations. In West Cork they found the Celtic mystical landscape, with its sense of otherworldliness and mystery, the very essence of timelessness and infinite creative possibility. The invisible saints became a recurring motif in Christa's drawing and sculpture. She saw in the ancient standing stones and ring forts the faces of the dead saints and they fascinated her. Christa was

below: *Gurteenakilla pottery stamp
on bottom of pot*
bottom: *Christa Reichel pottery stamp
on side of pot*

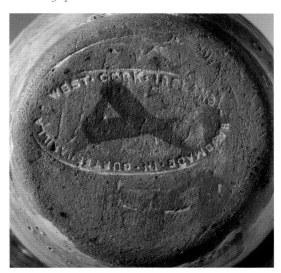

not a Christian; an atheistic upbringing had prepared a blank canvas for these mysterious Celtic gods to inscribe their presence in her imagination.

When Frank could no longer resist the lure of the young helper in the pottery, or of London, Christa found the strength to carry on alone their plan of making pottery, using the local clay dug from a pit on a farm in Ballinphellig, Ballinhassig, near Kinsale. Christa loved the idea of using the local red clay to make her ware. Her love of the landscape and of its clay, although rough and low-firing, was a real and powerful underlying theme which gave Christa's emerging aesthetic its powerful impetus. Her new partner in love and in business was a commercial artist, Nora Golden, whom she met in The Roslyn Arms on Haverstock Hill in North London. Nora took to the rough and ready freedoms of life in the mountains of West Cork. The couple found their talents to be extremely comple-mentary, able as Nora was as a draughtsman. Winters were spent pouring over facsimile copies of designs from *The Book of Kells*, sent to them by a librarian friend of Nora's in Brighton.

Pottery provided their bread and butter. A range of oval dish moulds were designed and made by Christa, drawing on her sculptor's skills for mould making. These drape moulds were a clever innovation as the dishes could be produced by relatively unskilled 'summer student labour'. Production began in earnest in the summer of 1965. The clay dishes were dried on ware boards, raw glazed with tin, and decorated using cobalt, copper, and iron oxides. Firing was to 1060 degrees centigrade in an electric kiln. Nora assisted at first in the pottery, mixing clay and decorating the

left to right: *Nora Golden, Dennis Murphy of Douglas Woollen Mills and Christa Reichel, late 60s*

dishes, however her batik wall hangings began to sell and a studio was converted for her from one of the other outbuildings with the aid of a small grant.

The Celtic motifs practised and learnt during those long winter months were applied riotously to the pottery dishes and to the batiks. The public loved them and proprietors from hotels, guest houses, and pubs from the entire West of Ireland flocked to the pottery to buy these lively decorative ceramics and wall hangings, hungry for the colour and novelty of this fresh Irish-made craftwork. The tourists found their way also and such were the

numbers visiting that Christa and Nora decided to open a small shop in Ballydehob in the summer of 1967. This small shop was the forerunner for the bigger enterprise that was to follow.

In 1968 they formed Ballydehob Artists Ltd. to open *The Flower House* which comprised a shop, a gallery, and workshops. This visionary enterprise gave the artists of the area a space in which to display and sell their work. It attracted art students, and young people from Northern Ireland, who travelled to the remote West Cork village to share in the raw creative energy that was fuelled by Christa's inclusive artistic vision.

Joseph Beuys, the intriguing conceptual artist, a fellow German damaged by the Second World War, shared Christa's vision in that famous phrase, 'Everyone is an artist'. 'Make Love not War', the phrase daubed onto the wall of the pottery in Gurteenakilla, was a similarly heartfelt response to the spirit or *zeitgeist* of the times. Christa embodied this spirit perfectly in her very being. Her powerful presence and dominant personality were attractive to those seeking an alternative way of life. Those same qualities could however be abrasive to those who came into conflict with her vision.

Conflict in Northern Ireland frightened away the ubiquitous English motoring tourists and forced her to close her business and lose her livelihood in 1970. She carried her vision of the joy of creativity into Cork City to continue her artistic and spiritual journey alone. That was a dark and bleak time for her, living as she had to in a rundown boarding house by the river, and working from a tiny shop premises.

Christa's was a true pioneering spirit. She was the first artist in West Cork of her generation to reach out to others, to touch and inspire them with her creative energy and encouragement. Christa consistently demonstrated her vision in her everyday life. She worked hard and lived her dream. She passed away on 18th May, 2009 aged seventy-seven years. In Cambridge she had finally found her place in the world, her home, and she was happy there. She never lost her vision and, although bound to a wheelchair, she kept a little kiln in her kitchen, and packets of clay on her shelves, 'her babies', soft and pliable, waiting for the touch of the true artist.

Patricia Howard
October 2010

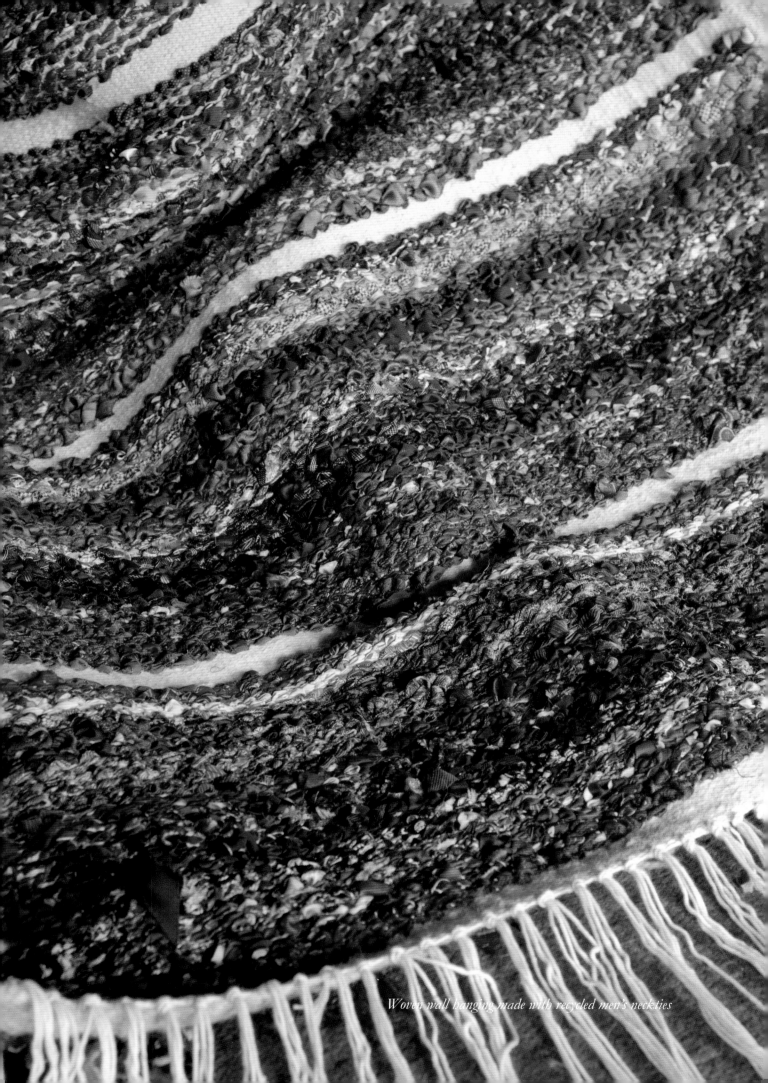

Woven wall hanging made with recycled men's neckties

Barbara Harte (1921-2007)
Weaver

Barbara made West Cork her home and wove herself into the fabric of life here.
Nina Harte

Barbara Harte was born in Sweden in 1921. She met her husband, West Cork native Ted Harte, in London and by 1949 they had moved to Bandon with their three young children, Nina, Johnny and Louise. In Stockholm, Barbara had been born into a wealthy family. Her grandfather was a businessman and her father, who was the youngest son, joined the family firm. In the 1930s due to the stock market crash and subsequent worldwide economic depression, Barbara who had been attending The French School in Stockholm, was taken out of school and took up

employment in the City Architects office. She was very happy there and loved the work, maintaining an enduring love for architecture throughout the rest of her life.

Barbara may have inherited an artistic eye from her grandmother who was a wig maker for the Stockholm Theatre. She was always interested in interior design, fashion, architecture and the arts in general. Whilst living in Bandon she ensured that her own children had the opportunity to attend dance classes and often took them to Cork to see concerts, dance performances and

theatre. She adored Ireland and in particular West Cork, observing the natural world at close quarters and really looking at the things that most of us pay little attention to like seeds, insects, plants and stones, to gather inspiration for her work.

Barbara became acquainted with fellow Swede Lily Bolin who ran a school of weaving in Cork and subsequently in Leeson Street, Dublin. Barbara decided she wanted to learn weaving and in 1964 they sold their house in Bandon and Barbara moved to Dublin with the children while Ted, who had a thriving timber business, stayed in Cork during the week and joined them for weekends. Barbara spent two years in Dublin and on the family's return to West Cork, she bought a loom (from Nora Golden, the batik artist and partner of Christa Reichel) and began to produce her own woven textiles. As she had trained with a Swedish weaver, her techniques and tying offs were recognisably Scandinavian. However her inspiration came from the natural world and very soon she developed a style of her own, based on the blending of Swedish weaving techniques with the colours and textures of West Cork.

Once Barbara had developed the skills for weaving, she turned her attention to learning carding, spinning and even dyeing. She was constantly trying out colours and would only start a project when she felt she had put the right colours together. In later years she began to experiment with stronger colours but for most of her life she used muted, natural, earthy tones. Her work was inspired by the colours and textures she saw in the landscape, in water, seaweed, rocks, stones, shadow and light.

*Weaving loom in Barbara Harte's workshop, West Cork
with wall hanging, wool and cotton yarns*

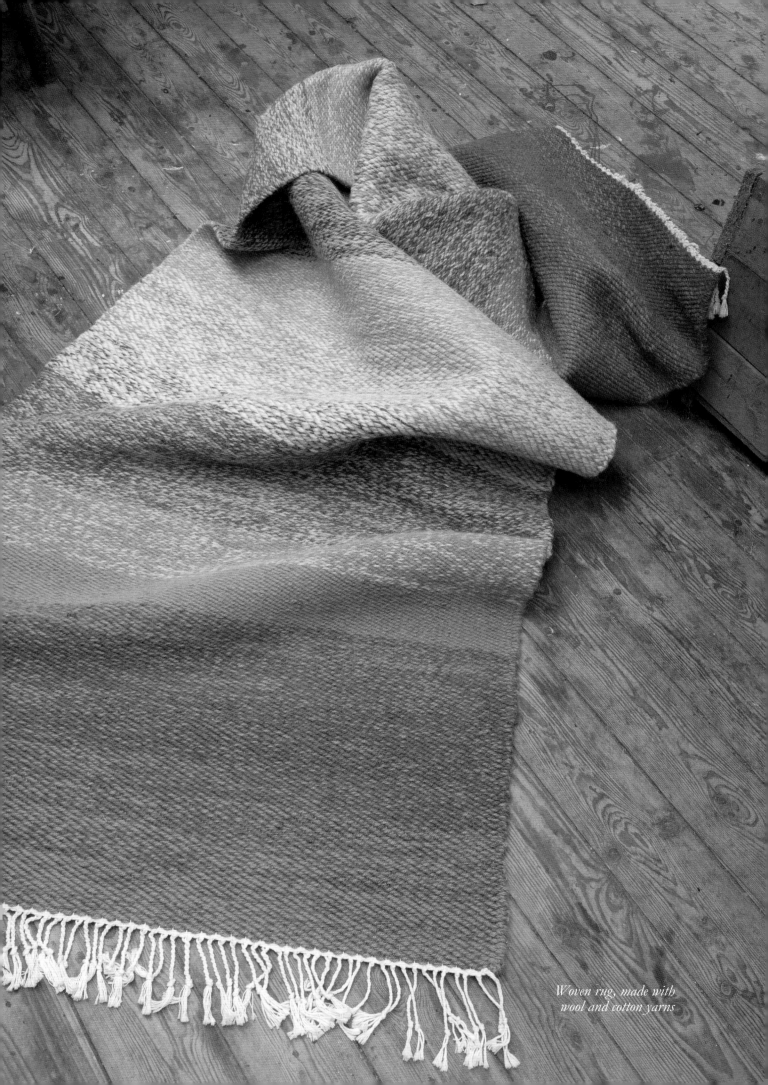

*Woven rug, made with
wool and cotton yarns*

Barbara Harte was deeply concerned with environmental issues and experimented with weaving using recycled and reused materials. She wove bathroom rugs out of plastic carrier bags and used recycled fabrics to create colourful rag rugs. A beautiful woven piece adorns the wall of her family's home, made from hundreds of men's ties which she collected from second-hand clothes shops. Barbara Harte continued to weave until the end of her life. She became renowned in her field and received commissions to make wall hangings, rugs and on one occasion, ecclesiastical robes for the Bishop of Kerry.

According to her eldest daughter Nina, 'although she never really became Irish, Barbara made West Cork her home and wove herself into the fabric of life here'. I never met Barbara but her family described a very determined woman, small and physically strong who was very conscious of her place in the natural world. She observed and she responded, her response was to weave and it felt like a natural thing to do. Like all crafts people, she put part of herself into everything she made and even though she has gone. I certainly felt her powerful presence in the beautiful work that remains.

left: *woven wall hanging* centre: *handspun undyed wool curtains*
right: *wall hanging made with recycled neckties and wool*

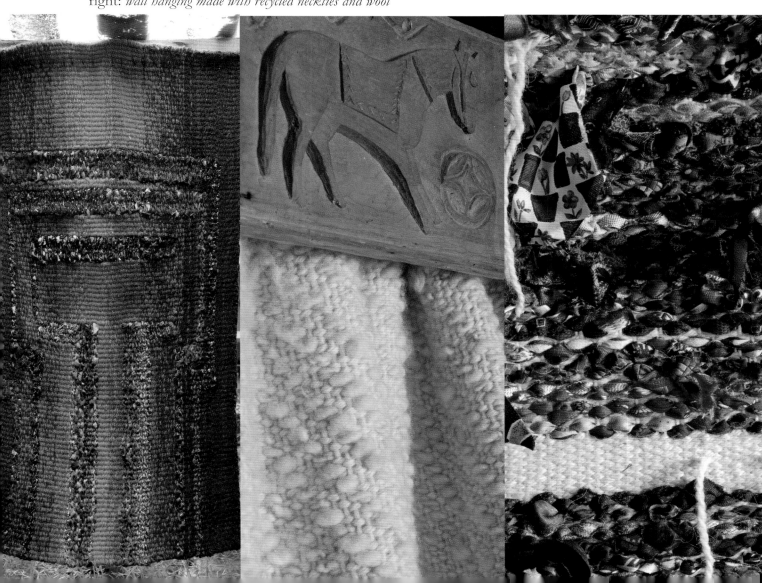

Leda May
Potter

When we first arrived here everything had to be imported, clay, kilns, glazes, equipment always took months to arrive so we just had to make do.
Leda May

Leda May grew up in a small Suffolk village and although her family, of Russian extraction, moved to London when she was fourteen, she had already developed an emotional connection with the countryside that continues to influence her work today. Following the completion of her National Diploma in Fine Arts and Design in 1967 at Hornsea College of Art, Leda spent two

years teaching on an adult education course in the Central London Institute, Holborn. At the time studio pottery was not considered viable and training was intended to prepare graduates for the Royal College of Art or for more industrial, commercial work.

However, studio pottery began to seriously take off in the 60s and 70s. This is where

previous page: *House hand built in stoneware clay, 1984*

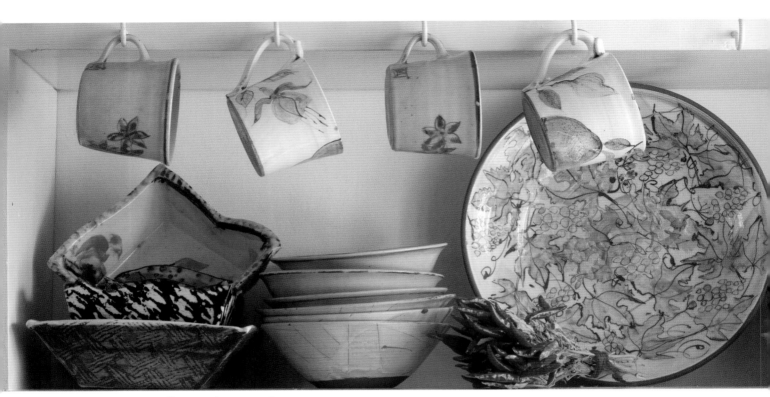

Artists collection of own work.

potters or ceramic artists who either work alone or with a small number of employees carry out all stages of production from design, to throwing on the wheel or hand building to glazing and firing in the kiln. A studio usually specialises in small batch production or one-off pieces that would be sold direct to customers.

Leda recalls visiting the first modern pottery shop to appear in London. This was *The Craftsmen Potters Shop* which opened at 3 Lowndes Court, off Carnaby Street in the heart of London's West End. The shop belonged to the Craftsmen Potters Association (Roger Turner, father of Leda's fellow West Cork potter Jim Turner, was very involved in its set up and management). This marked the beginning of a revolution in pottery production, with studio pottery becoming popular throughout Europe and America.

Leda and her husband Bob arrived in West Cork in the late 60s, having packed their possessions into an old converted ambulance, bent on visiting all the potters in Ireland. The Tourist Board could offer very little information on how many potters were living and working in the country at the time. They managed to put together a travel itinerary which took them first to visit Helena and Peter Brennan in Dun Laoghaire, who were running Ireland's first high-fired stoneware and porcelain studio. From there they headed south to visit Sonja Landweer in Kilkenny. At that time, Sonja Landweer had recently arrived in Ireland from Amsterdam, having been invited to set up a ceramic studio at the Kilkenny Design Workshops.

They eventually arrived in Ballydehob where they met Christa Reichel, whose pottery studio had been established in Gurteenakilla since the early 60's. She invited them to stay and generously offered them space to set up a pottery of their own behind her shop. Leda felt drawn to the West Cork landscape, the environment fired

her with inspiration and she was delighted to be offered an opportunity that would allow her to stay and start making and selling her own work. Leda recalls enjoying the slow pace of life in Ballydehob. 'Life was very simple in West Cork in the 1960s. Most people did not own cars and travelled on foot or by donkey and cart. No one really went very far afield, entertainment consisted of evenings in the pub or meeting friends for a game of cards.'

Leda and Bob were founder members of the Cork Craftsman's Guild and sold their work through its shops in Cork and Dublin for several years. Leda was also involved with the Society of Cork Potters and participated in their regular workshops and the annual exhibitions at the Crawford Gallery in Cork. During the summer months Leda ran a programme of pottery courses for children and adults from her studio in Ballydehob. These were mostly

Earthenware tile with hand painted slip decoration

advertised by posters and signs which were designed and printed by local craftspeople and placed in shop windows and on notice boards. In this manner Leda taught a number of local people to work with clay, some of whom continued classes for several years. Today craft classes may seem quite commonplace but in West Cork during the 1960s the idea was very innovative and exciting.

Leda's work has clearly progressed through several phases: her early stoneware with its earthy hues and rough textures was influenced by primitive art with symbolic religious or magical motifs and highly expressive forms. She is perhaps best known for her accomplished brush work and surface decoration akin to Delftware and Chinese porcelain. Painting directly onto dry porcelain with glaze requires a

Earthenware plates with cobalt blue decoration, 2010

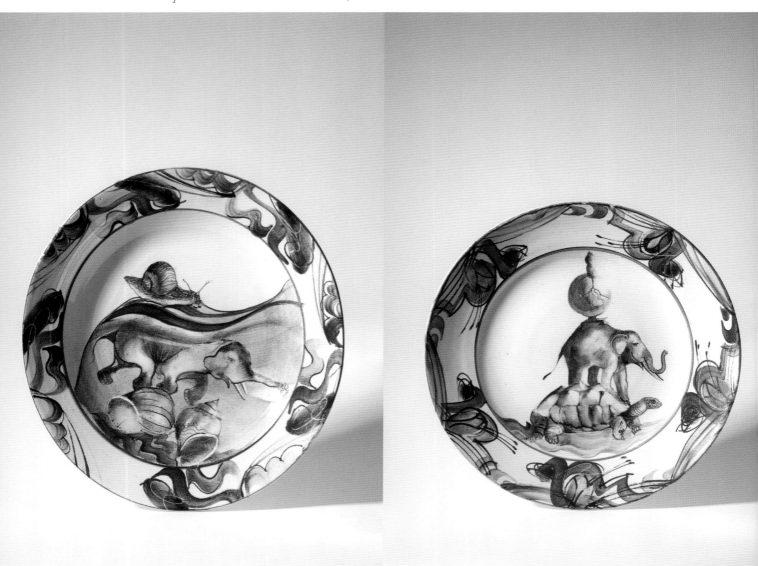

confident and fluid technique. According to Leda, 'you only have one chance to get it right'. Many of her decorated pieces from that era show a remarkable sense of spatial awareness and balance.

Like many of her counterparts, the marketing and selling of her ceramic work was never a driving force for Leda. She has always made work in small batches and is motivated by the desire to express herself artistically rather than by making a living. Local collectors of her work treasure the pieces they own, knowing very well that each one is unique and irreplacable.

left: *porcelain bowl with cobalt decoration and celadon glaze, 1982*
right: *porcelain jug with cobalt decoration and celadon glaze, 1980*

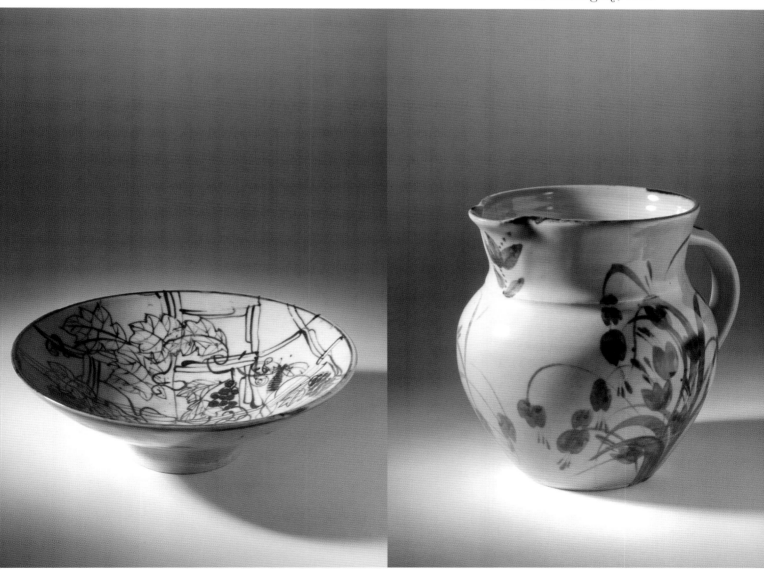

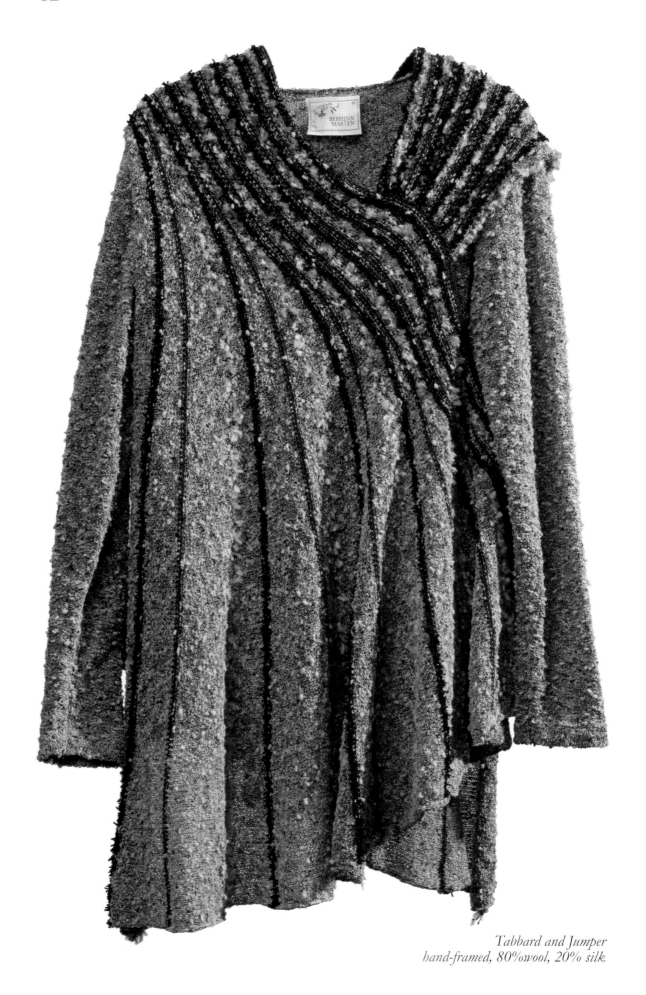

Tabbard and Jumper
hand-framed, 80%owool, 20% silk

Bebhinn Marten
Designer

Cork Craftsman's Guild had a very good team, we had the right group of people at the right time.
Bebhinn Marten

Facing onto a garden of beautiful flowers with views over the estuary towards Baltimore, Bebhinn Marten's small factory and design studio is perfectly placed for West Cork inspiration. The colours, the shadows and the light change with every season, the hues of the West Cork seascape, stone greys and aquatic blues, inevitably weave their way into her garments. The daughter of artist parents, Bebhinn's father was Seamus Murphy, renowned sculptor

and professor of Sculpture at RHA, and her maternal grandfather was Joseph Higgins, notable painter and sculptor from Cork.

Bebhinn left school aged 15 and went to work for *Elizabeth Jones*, a couture business, manufacturing and designing fashionable women's clothing. She had a natural flair for the work but did not particularly enjoy the couture trade and subsequently moved to Kildare, working for a children's knitwear

manufacturer. Here she was apprenticed to a designer and learnt pattern making, and cutting, fundamentals for the textiles trade.

Two years later at age 17, Bebhinn applied for a job closer to home, in the West Cork firm *Carbery Tweed* which had its headquarters at St Patrick's Woollen Mills in

Douglas, Cork. One condition of the job was that she could drive and as she wanted the job so much, she told them she had a licence. Bebhinn landed the job and duly went to City Hall to purchase her £2 driving licence (there were no driving tests at that time). The owners provided her with a turquoise Mini which she learnt to drive on

Scotty Dog
hand-framed, 100% Donegal wool

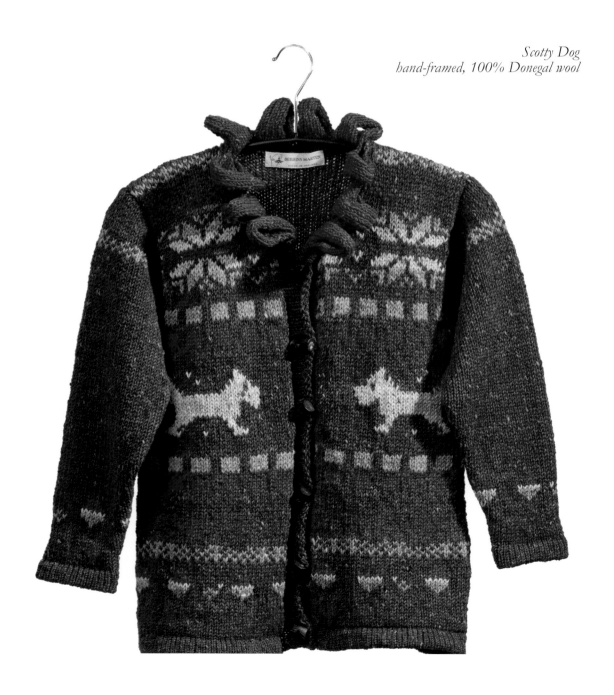

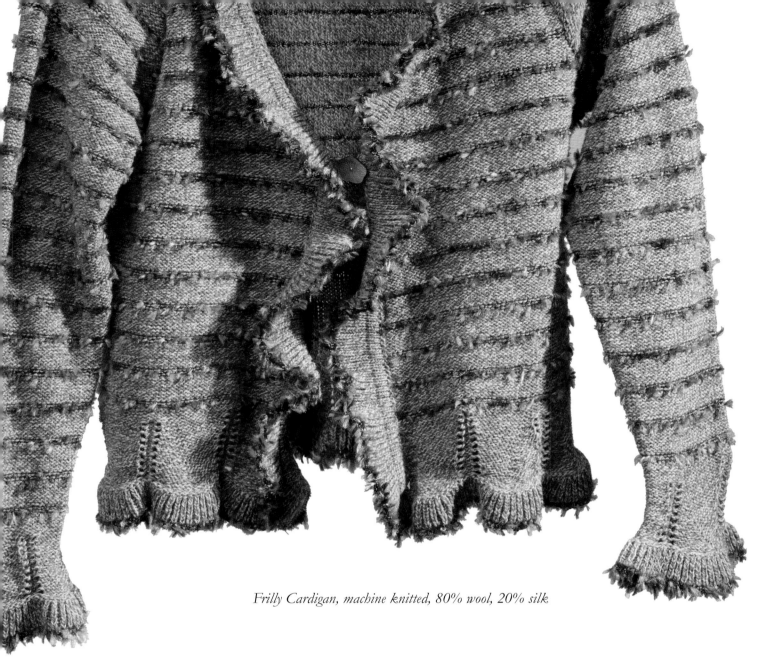

Frilly Cardigan, machine knitted, 80% wool, 20% silk

a nine hour trip to Galway one Monday morning, learning how to change gears along the way.

Carbery Tweed specialised in producing hand-knitted Aran sweaters for children as well as manufacturing tweed cloth. Their products had a large market in the US. They employed up to two hundred hand knitters working from home and scattered across the whole county, from Macroom to Clonakilty and down to Castletownbere, north east to Mitchelstown and Midleton. Yarn and patterns were distributed and collected through a complex system of deliveries and collection points, where the women knitters would meet the supervisor, sometimes at a windswept crossroads with

the bag of completed garments in one hand, whilst collecting the new yarn and patterns with the other. The work was mostly carried out by women and was seen as a way to supplement the family income, an alternative to 'keeping a few hens'.

Bebhinn was part of an Irish delegation, organised by the Irish Export Board, which visited the United States for a month-long visit, twice a year. The delegation would visit stores in fifty cities during a whirlwind tour, meeting with buyers and sometimes mounting makeshift exhibitions in hotel bedrooms.

In 1969, Bebhinn married and moved to Baltimore where she set up her own small

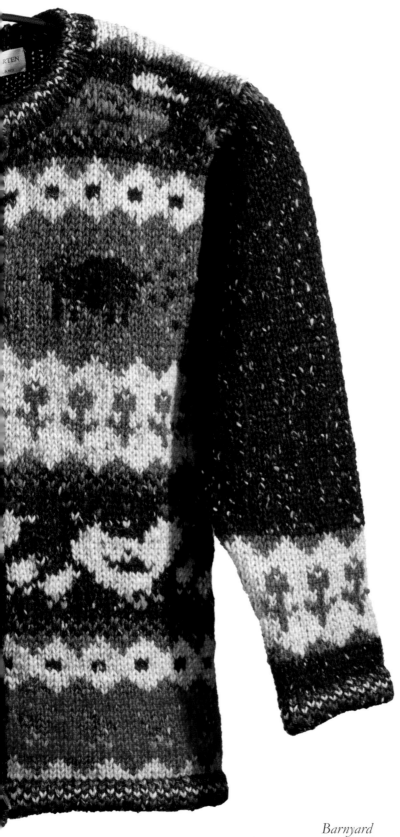

Barnyard
hand-framed, 100% Donegal wool

business. She started by making hand-knitted Aran cushion covers as well as cutting, making and trimming cushion covers for a company in Cork. She employed local hand knitters. By degrees she started working with knitting machines and in the mid-1970s designed a range of sailing and yachting wear which proved very successful. The range combined cosiness and practicality with being hard-wearing and beautifully made.

Widening her focus, Bebhinn began adding to the collection and designing new ranges of fashion knitwear, introducing new colours and designs for each season. This area is very competitive and *Beacon Designs* has kept its place in the market by developing a excellent reputation in Ireland and overseas for quality of design, production and finish, which are second to none. Bebhinn comments, 'The clothing business is not easy, products need to be well crafted and commercially viable, you need to know which shapes and colours will be fashionable well in advance of the season'.

Alongside her design work, Bebhinn was a founder member of the Cork Craftsmen's Guild when it was established as a co-operative in 1973 and remained with the group until its demise in 1984. She recollects that the original group was made up of very committed and successful makers whose work sold well and only needed a suitable retail outlet to promote, market and sell their products in Cork city. She took her turn in many roles within the co-operative, attended meetings and was deeply involved in the running of both shops.

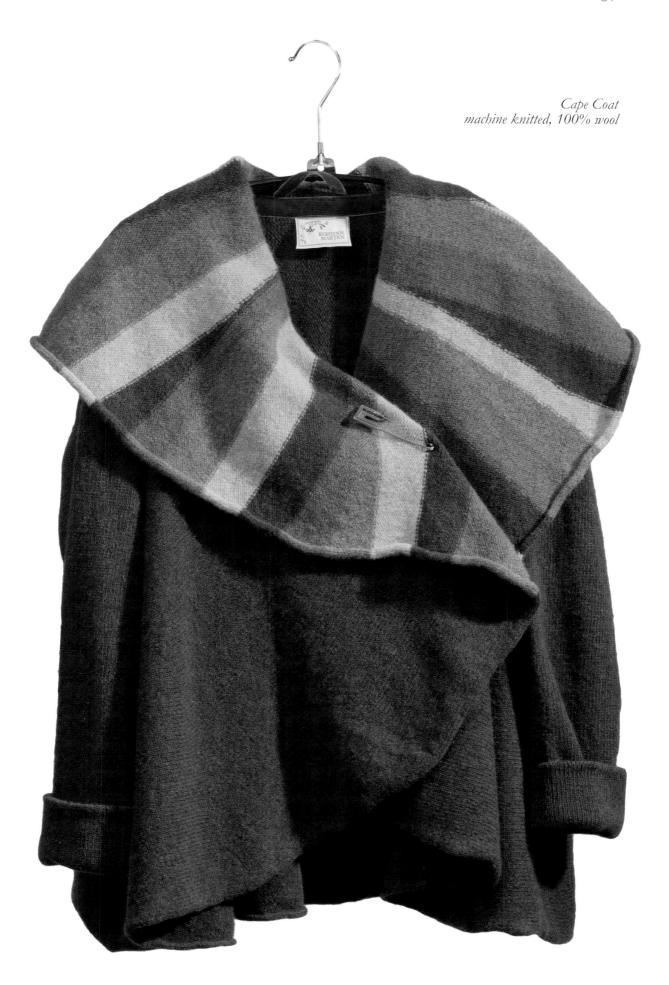

Cape Coat
machine knitted, 100% wool

Barley Lake

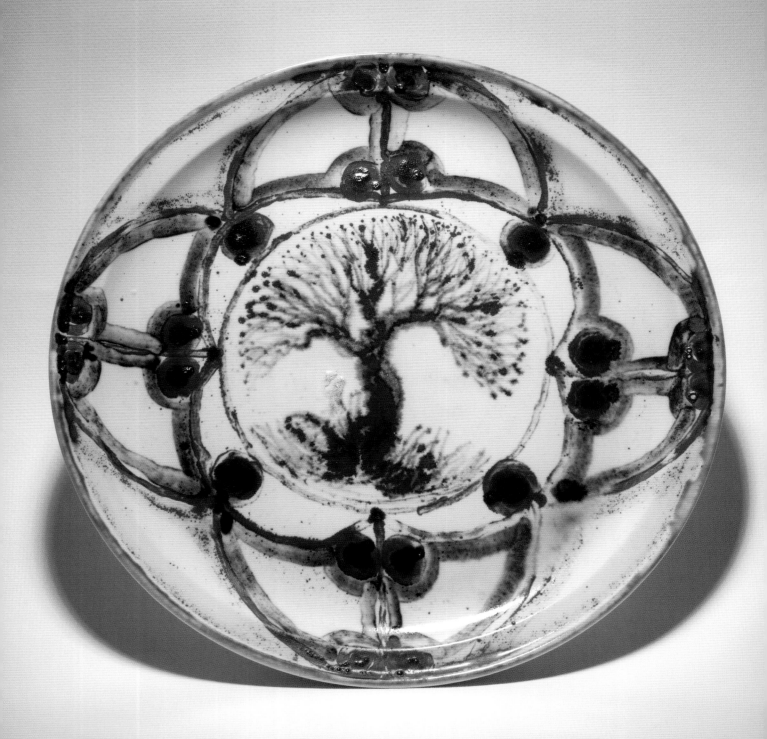

Winter Tree, earthenware and oxides

John Verling (1943-2009)
Artist, ceramicist, print maker

It was hard-going here before the Craft Council was formed — until then we had no one to champion our cause.
Noelle Verling

John and Noelle Verling moved to West Cork in 1971. Some years earlier, John had studied for an architecture qualification at the Crawford Municipal School of Art in Cork. His teachers and course work there exposed him to a variety of artistic experience not only in architectural drawing but also in ceramics, print making and fine art. John was a prolific artist, as much at home with his drawings and tempera paintings as in the workshop producing ceramics. His fascination with the built environment is evident in much of his work and became a signature in his paintings. His exquisite set of building prints produced to commemorate the writer Edith Somerville are an outstanding example of his ability to both accurately represent buildings and to recreate the unique atmosphere of Castletownshend village.

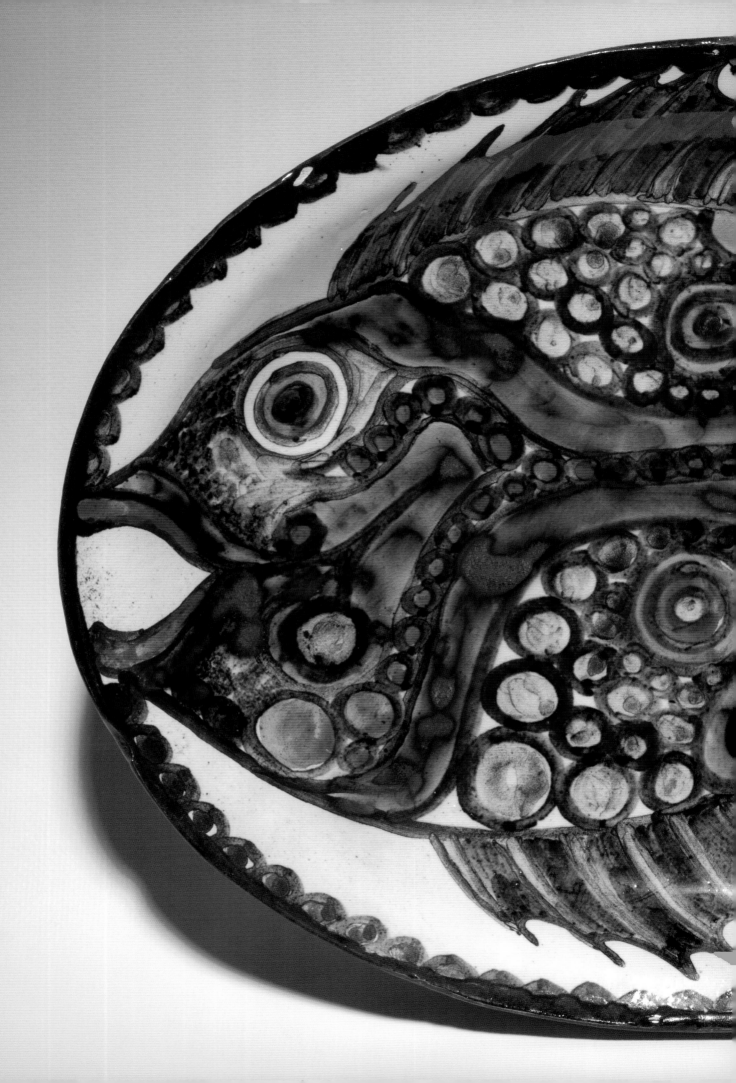

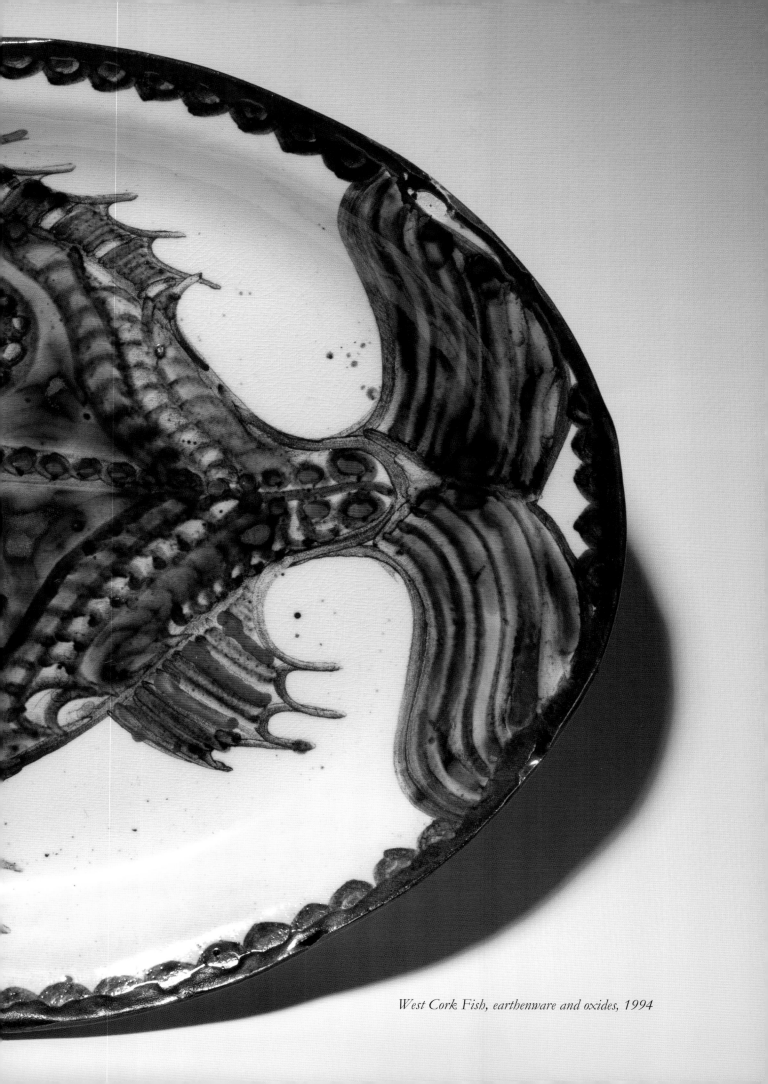

West Cork Fish, earthenware and oxides, 1994

John, along with his friend and fellow student Brian Lalor, had spent time in London where they mixed with a disparate group of artists, poets, painters and musicians. John qualified as an architect but maintained an open mind and a voracious appetite for all artistic practice. John's potter wife Noelle went to Hammersmith College of Art to study ceramics and when they returned to Ireland, after a spell of full-time architectural practice, they established their own studio pottery, first in Dripsey and later in Gurteenakilla, near Ballydehob, West Cork.

The Verlings first met Christa Reichel when they set up their pottery studio in Dripsey. At the time, because there were very few pottery workshops in Ireland, they were obliged to import all the necessary equipment and raw materials from the UK. When the equipment arrived John and Noelle found that the essential potter's wheel was missing. By chance they had heard that Christa Reichel was winding up her business near Ballydehob and selling her equipment. At first they bought her potter's wheel and eventually bought the whole premises. On moving into Gurteenakilla they inherited some of the moulds that Christa had been using for making bowls and platters over the previous ten years.

John Verling loved the windswept West Cork landscape and felt moved to record a disappearing environment. His paintings often depicted the doors, windows and walls of decaying buildings, repositories for the memories of past inhabitants, long gone. His ceramics are instantly recognisable by their vivid pictorial decoration, brightly coloured fish or lobsters grace the surfaces of large platters and bowls. The windswept thorn tree is another familiar motif which connects John Verling with West Cork. The tree became his icon and frequently appeared in his paintings and on his ceramic work.

From Gurteenakilla he and Noelle sold their work direct to the public as well as supplying a number of retail outlets throughout the country. John and Noelle Verling were founder members of the Cork Craftsmen's Guild and contributed much of their time to the running of the organisation. John represented the Guild as a member of the Craft Council of Ireland for several years. They were also members of the Society of Cork Potters joining in group exhibitions and attending social events and workshops.

John Verling was an exceptional artist who produced a wide range of work over many years. His paintings, prints, illustrations and ceramic work form an important part of West Cork's artistic heritage.

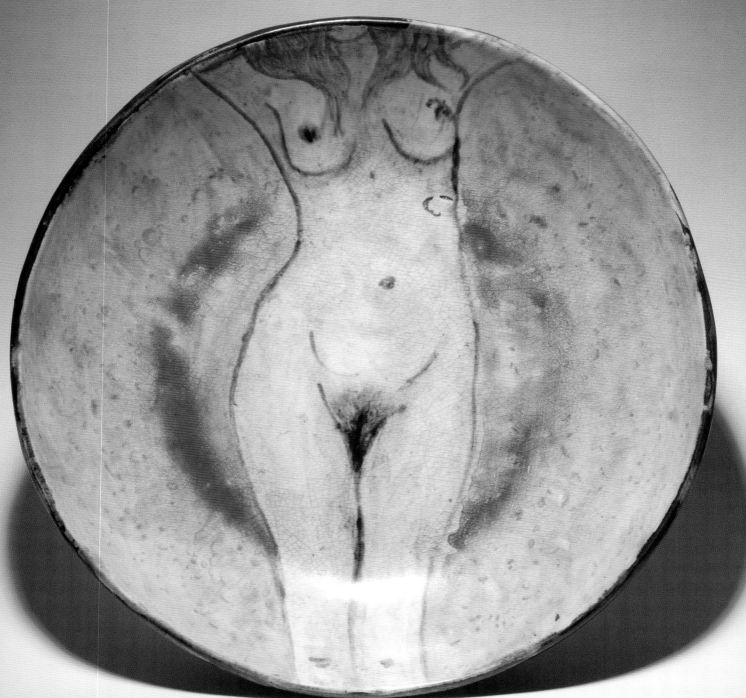

Lady in Red, underglaze decoration, 1998

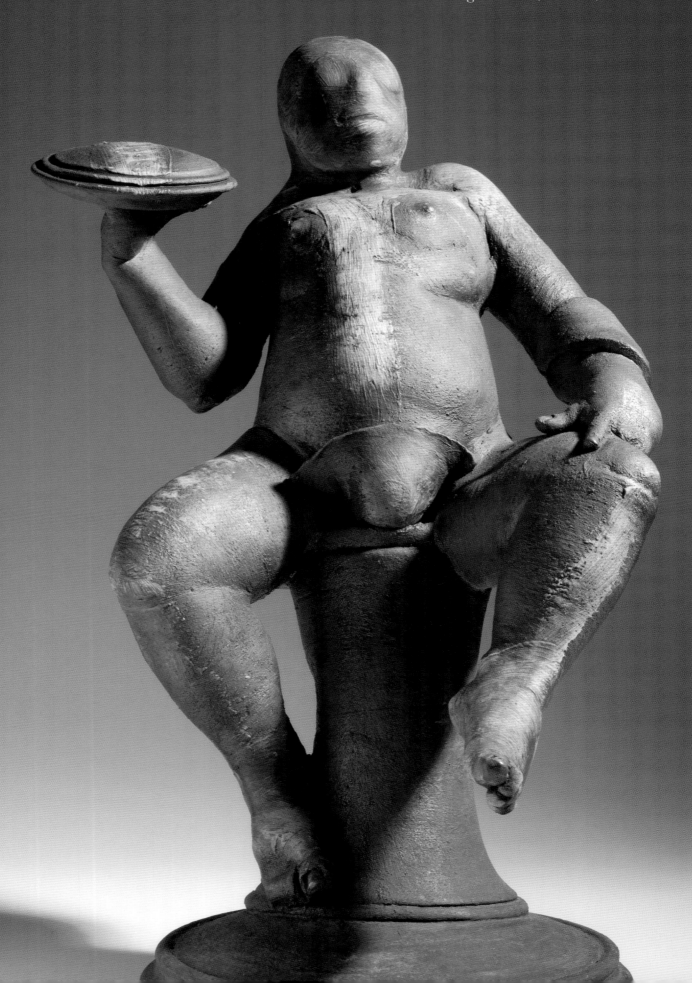

Aboriginal Waiter , stoneware, 1992

Pat Connor
Artist

Being a potter wasn't a business back then, it was a wonderful way of life.
Pat Connor

Pat Connor is a multi-talented artist who can turn his hand to illustration, painting with oils or watercolours and printing as well as making ceramics. He was amongst the earliest pioneers of the craft movement in West Cork, being a contemporary of Christa Reichel and Nora Golden. He graduated from the National College of Art and Design in Dublin and has since produced works in paint, print, pencil and ceramics including sculpture and tableware.

Inspired by the work of Alberto Giacometti, Pat manipulates thrown forms into figures of various shapes and sizes. 'I like to make my figures out of thrown sections and manipulate them into shape.'

He is an exceptionally skilled ceramicist who learnt to throw after finishing college when he was apprenticed to a potter for several months. Throwing is the process of shaping clay as it spins on the potter's wheel

Pat Connor at work in his studio, 2010

and repetitive practice is necessary to develop expertise. For many years Pat produced a range of high quality tableware which he sold through the *Cork Craftsman's Guild* shops and from his own studio. Alongside the tableware, he continued making figurative pieces which have always represented his more expressive work.

In 1971 Pat was working in Dublin and made the decision to move to West Cork and join the emerging creative community centred around Ballydehob. Pat and his wife Adele bought a tiny cottage with an adjoining workshop next to a fast-flowing stream, just outside of Schull. Over the

years they have extended the house and developed a large pottery studio where Pat has been making and selling his work for almost 40 years.

Pat recalls, 'back in those days, there was not much of anything around here. People were relatively poor, houses were cheap. We put a sign out on the road and people would drive past and stop and buy. In the summer we were always relatively well off, due to the tourists, especially from the UK and Germany'. In the winter months Pat would go to Dublin to sell his sculptural work in shops and galleries. His sculptural work, focuses mostly on masks, busts and the

human head, each unique facial expression evocative of the human condition – fierce, peaceful, tormented and humorous.

As there were large numbers of people visiting West Cork, the exceptional work being produced in the area was recognised both nationally and internationally. Along with exhibitions in Cork and Dublin, high profile exhibitions were organised, taking the artists on two occasions to exhibit their work in Switzerland. During the 1980s a new facility opened in West Cork, *The West Cork Arts Centre*, which provided artists with a local venue in which to show and sell their work.

Pat was a founder member of the Cork Craftsman's Guild and sold his work through the shop in Cork for many years. He was also a member of the Society of Cork Potters and took part in the 1982 International Symposium as well as participating in workshops and events including annual exhibitions at the Crawford Art Gallery in Cork. He participated in the 1980 Paris Biennale and he has pieces in the National Museum collection as well as in private collections such as the Bank of Ireland and Allied Irish Bank.

It is a rare pleasure to watch Pat Connor at work as he is a real master of his materials,

his hands rapidly shaping and forming the clay into a living form, not necessarily one we might recognise but maybe a figure from his imagination. He talks of other things while his hands seem to act of their own accord and in a very short time, a figure emerges. Pat uses stoneware clay and simple glazes that contain copper and iron oxides, and sometimes coloured slips.

The artist's home is filled with his work including paintings, prints, pots and figures he has created over the years. There is an organic feel to the curves and outlines of his functional earthenware vessels but his walls and shelves are also peopled by edgy characters, some in truly tormented poses. They are like statues of living creatures turned suddenly to stone, caught mid-sentence, mid-expression or mid-gesture, slightly cock-eyed and entirely original.

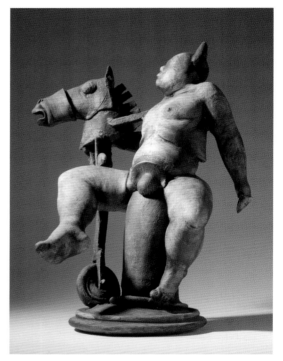

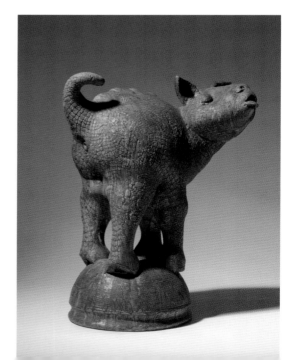

top: *Head, stoneware, 2005*
middle: *Ride a Cock Horse, stoneware, 1989*
right: *Blue Dog, stoneware, 2005*

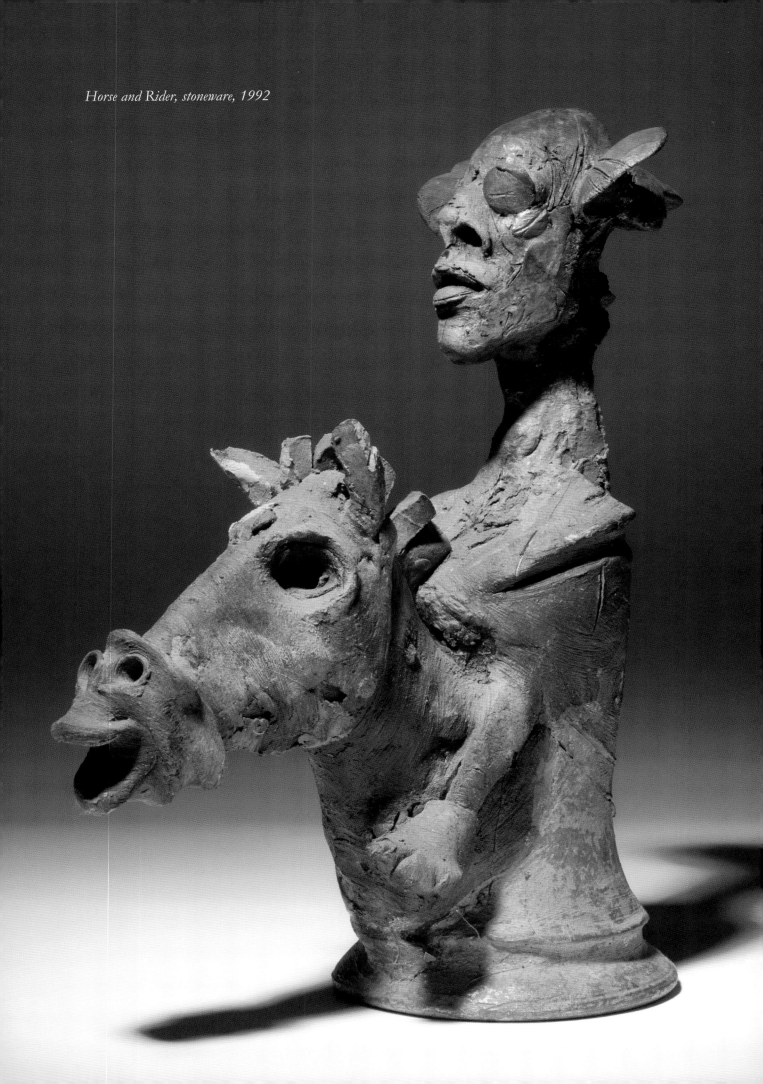

Horse and Rider, stoneware, 1992

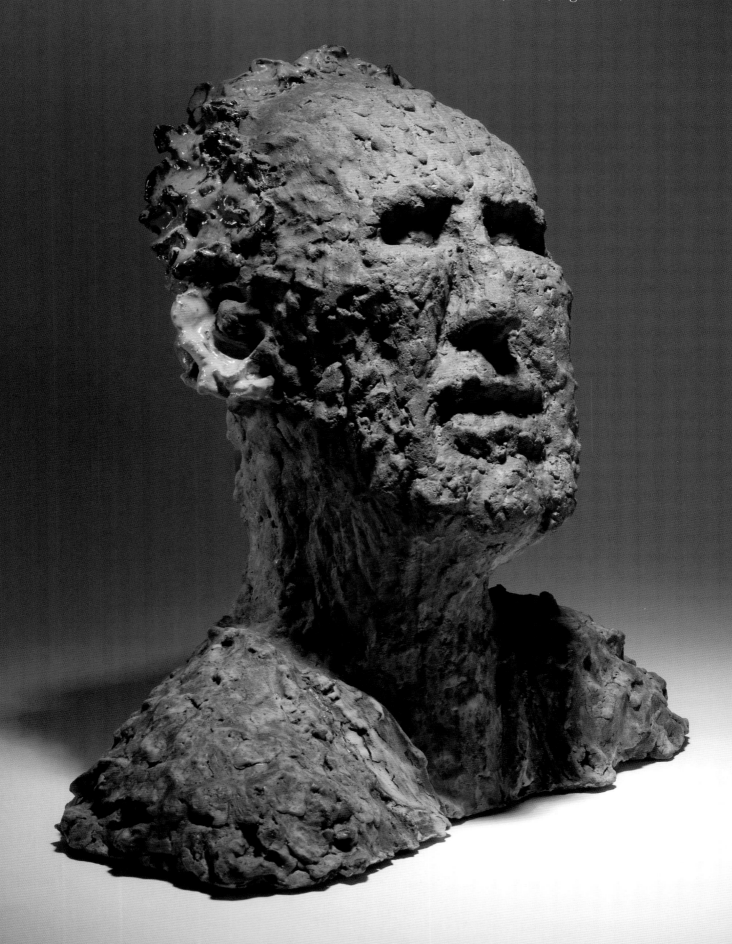

Seán O'Conail, ceramic, height 46cm, 2004

Cormac Boydell
Artist working in clay

When I started to make work that came from my soul, that's when things started to happen for me, it was an important lesson.

Cormac Boydell

From an early age, Cormac Boydell was aware of work produced by various ceramic artists. His parents owned a collection of John Ffrench's work and were frequent visitors to the studio of Grattan and Madeline Frear in Foxford. At school Cormac attended art classes with one of Ireland's most prominent sculptors Oisín Kelly, an inspirational teacher who first introduced him to the idea of working with clay. Cormac subsequently studied Geology at Trinity College Dublin and worked as a geologist in Australia but found the work unsatisfying and longed instead to pursue something more creative. In 1972 he came back to Ireland, bought 'a shell of a house' near Allihies and proceeded to build a kiln and learn more about working with clay.

Cormac Boydell preparing terracotta clay

Cormac's love of Ireland's extreme south west corner began during the 1960s when his family bought a caravan and started to visit the area on a regular basis. He found the landscape strikingly beautiful and felt a strong connection to the wild and rugged coastline, partly instilled by the Blasket Islands and its writers Ó Criomhthain, Sayers and Ó Súilleabháin. (The Irish speaking population of the Blaskets, off the west coast of Kerry, were evacuated in 1953 but they leave behind a rich heritage of anthropological and linguistic studies. The islanders epitomised a community in which life was reduced to fundamentals, what Declan Kiberd calls 'mankind pitted against nature'.) When Cormac finally returned to Ireland, he was certain that Allihies, at the tip of the Beara Peninsula, was where he wanted to be.

The creative work that has emerged from Cormac's return to West Cork, has its roots and soul in the very earth of the country. Prehistoric and tribal art inspire his work which is often pared back to the elemental: clay, glazes – made from earth minerals – and the invisible element, fire. Through kneading, folding and manipulating the clay, he has developed an intense relationship with his material and a freedom, born of knowledge, when devising and applying glazes. His contribution is the creative process – the expression of his experience.

Having built a kiln at the outset, Cormac spent several years experimenting with clay, glazes and hand building techniques. Learning to work with clay requires the artist to respect a different time frame as it is a slow, demanding process. Cormac enjoys the pace of work and feels attuned to working *with* the clay, allowing his material to dictate the rules. He chooses not to throw on the wheel, his hands are his tools, making direct contact with the clay, shaping through touch and instinct. The material is free to express itself and edges are left rough and chunky and thus reveal the making process.

In the south of Ireland there are few sources of natural clay but deposits of earthenware clay are found at Carley's Bridge in Enniscorthy, County Wexford. It is a 'rough clay with a strong body' and fires to a rich terracotta colour. 'I think it is crazy to import clay when we have such beautiful clays in this country. I like to use materials that come out of the ground from as nearby as possible. If things are connected

to the place they come from, they have a kind of life within them.'

The process used for shaping the clay for his platters and bowls somewhat resembles the making of a pastry crust. The rolled out clay is left on newspaper to dry until it can hold its shape while remaining flexible. It is then placed on a shallow 'form' and left to dry. After this, a 'foot' or stand is added underneath. Each piece is then signed and numbered before firing and glazing. Glazing is done in layers with separate firings at different temperatures for each colour, the

Boyle Abbey – Terracotta, 40x36cm

Allibies Races – Terracotta, 31x26cm

Claudio Monteverdi – Terracotta, 26x24cm

White Lines – Terracotta, 21x18cm

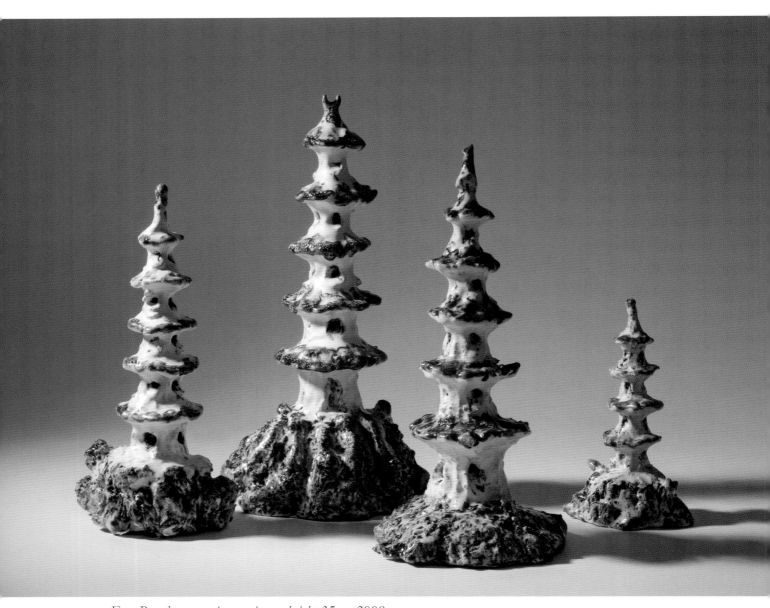

Four Pagodas, ceramic, maximum height 35cm, 2008

underneath colour changing each time another layer is added. The powerful transformations that occur in the kiln can only be predicted and controlled in some measure. Cormac enjoys the firing process as 'you never know what's going to come out....it's often a surprise, the wonderful pleasure of the unexpected.'

The surface decoration of Cormac Boydell's platters frequently includes the heads and faces of men. It is a commonly used motif in Ancient Celtic art. Celtic warriors attached symbolic importance to the human head and it is possible that this motif was used as a kind of talisman. In Cormac's work, it allows him to explore a

variety of themes in the finish and decoration of his work. He is presently working on a series of dishes decorated with portraits of selected composers. His line drawings on paper are accomplished but his skill in surface decoration is best demonstrated when working with glazes that behave unpredictably in the kiln. Much of his work is richly glazed with vibrant colour, often incorporating edges and details in gold enamel and metallic lustres.

In 1983, Cormac decided to start officially working as an artist and set out to earn a living by selling his work. At first, he looked at the market to see what might be popular and above all what kind of product was likely to sell. Most of his early pieces were made with a functional purpose in mind, with glazes that were washable and non-toxic so that they could be used in the kitchen. He subsequently found that people were hanging his work on the wall, a discovery that gave him the freedom to work with a wider variety of textures and glazes without consideration of their practical applications. During the 1980s Cormac joined the Society of Cork Potters and took part in some of their workshops and exhibitions but his location made it impossible to participate in regular social events.

Although sales of work were slow in the beginning, in 1983 Cormac was invited by Michael Robinson to exhibit at the Ulster Museum, in a show called *New Irish Ceramics*. West Cork artists Ian and Lynn Wright and Pat Connor also participated in the exhibition which travelled to the Bank of

Ireland in Baggot Street, Dublin in 1984. It was a very innovative and successful exhibition which generated good sales for the artists and promoted their work in Northern Ireland and the Republic. Cormac continued to submit images of his work to international magazines and exhibitions resulting in his work being shown at the Art et Objet in Paris.

The home of Cormac and his artist wife Rachel Parry is like an oasis, nestling into the hillside, among beautifully cultivated gardens and protected from the prevailing winds by shrubs and trees. Although his work is not conceptual, the surrounding landscape inevitably feeds its way into his pieces and can be observed in the rugged textures and colour palette he employs. Cormac feels there are real benefits from working in this environment and that it facilitates his artistic output. 'As a reclusive artist I don't get diverted by continually seeing things that make me think I should be trying something new.' He enjoys knowing that his artist neighbours are toiling away in their own studios nearby, even though when they do meet up they rarely talk about their work. Cormac's work is organic and elemental, the earth is its source. It resonates across millennia from when the bedrock of this country was being laid down and speaks of torsion and vortices, glacial drift and the alchemy of fire. It taps into the energies of nature, to which it is inextricably linked. His work is represented in numerous public collections, including the National Museum of Ireland, the Ulster Museum, Belfast and the National Self Portrait Collection.

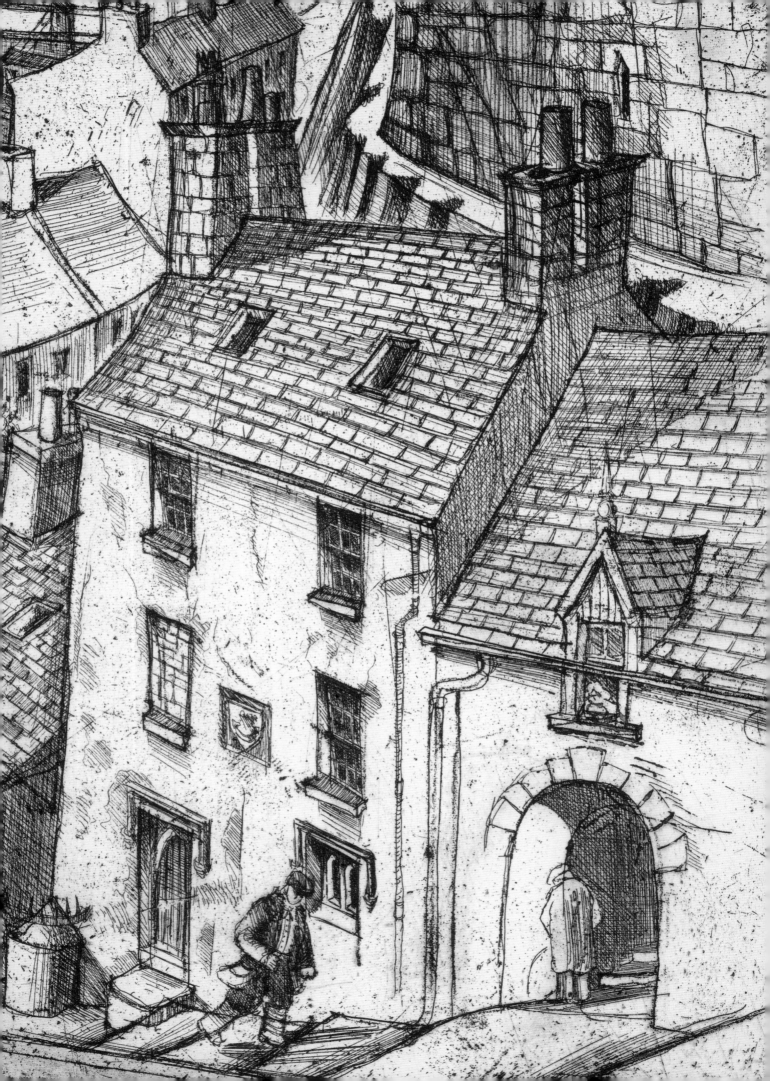

Brian Lalor
Artist, printmaker, writer

Kierkegaard observed that 'we think backward but live forward'. In West Cork then, we did the opposite – thinking forward because we were idealists, but living backwards in the retreat from the city and a mechanical world.
Brian Lalor

Brian Lalor is an artist of many talents. He is well known for his faithful recordings of the rural and urban landscapes of Ireland past and present, through his meticulous wood and lino cuts, etchings and mezzotints. Brian moved to West Cork with his wife Claire in 1973 and all their children were born in West Cork. They bought a small farmhouse near Ballydehob where Brian had his print studio and supported his family by marketing his prints in shops and through exhibitions in galleries. Local craft shop owner, Eileen Byrne, clearly recalls selling his prints inspired by local landmarks, such as the famous Two Trees landmark in Castletownshend.

When Brian moved to West Cork he was already well acquainted with painter and ceramicist John Verling. Together they had

previous page: *The Fall of Icarus (detail), etching and sandpaper aquatint, 52x73cm, 1980*

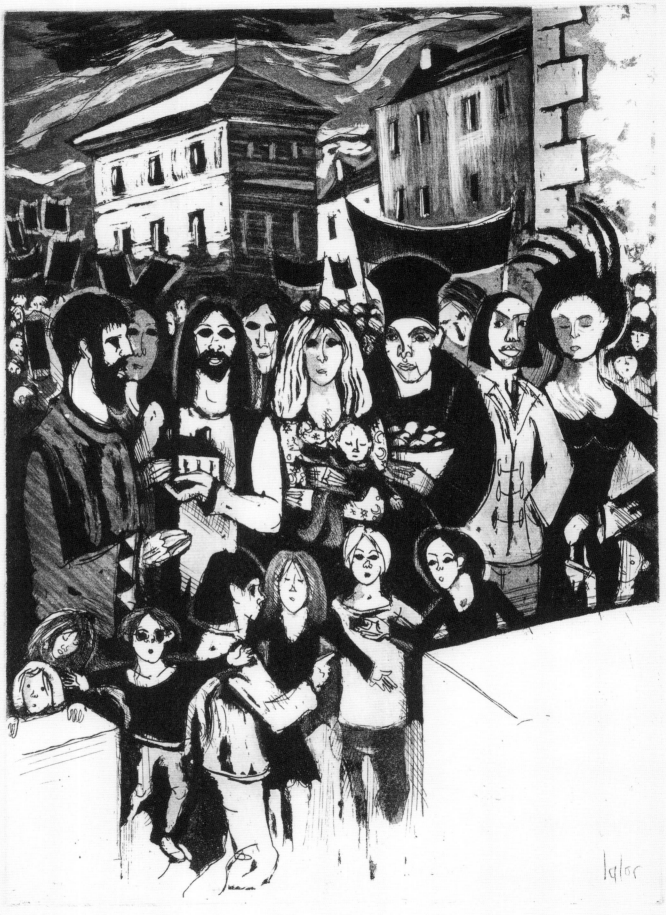

HP THE CEREMONY of INNOCENCE lalor
2009

enrolled as architectural students in the Crawford Municipal School of Art during the early 1960s and continued their architectural studies in London, where both took the opportunity to explore a wide range of artistic media.

After graduation Brian spent several years travelling, working in Germany, Greece and Israel (he was an archaeologist in Jerusalem). Having been an ardent collector of old prints for many years, Brian set out determinedly to learn the arts of etching and print making while he was based in Jerusalem. He believed that by knowing how the print was made and understanding the techniques behind it, he would have a better appreciation of the works in his collection.

Now settled in West Cork, Brian made regular forays on his bicycle, into the countryside, sketch book in hand looking for inspiration and a vantage point from which to observe and sketch. In his book *West of West*, which contains 90 of his own etchings, Brian recalls how, on two occasions, Kilcoe Castle made 'attempts' on his life. He lived quite close to the castle and soon discovered that much of it remained intact, with stairs, partial floors and windows. He was able to enter the upstairs rooms, which had magnificent views across Roaring Water Bay and muse about the people who had lived there centuries before.

On one occasion, having found what looked like the remains of a dungeon, Brian jumped down to investigate, only to realise to his horror, there was no way out. By pure chance he found a handful of large silver nails in his bag and by hammering them into the wall with a stone, made good his escape. Years later, whilst drawing the view from the third floor and with eyes fixed on the horizon, he stepped forward and found himself teetering dangerously on the edge, glancing down to certain death on the rocks below.

Brian's eye was attracted by the detail in the West Cork landscapes: oddly shaped fields, rocky outcrops and promontories, fairy rings and the play of shadow and light. These feature abundantly in his accomplished prints, often alongside man-made detail: roofless sheds, clusters of buildings, ivy clad ruins and meandering stone walls. His skill as sketcher and meticulous draughtsman is apparent in all of his work. Whether the subject is topographical or the built environment, his prints contain an atmosphere of place almost as vivid as the lines on the page. Silvery moonlight, smoking chimneys, ghostly ruins, a landscape suffused with memories of times and people since departed.

Humanity is depicted with all its foibles and eccentricities in much of Brian's work. His Breugelesque town scenes attract the eye to every corner with comic details, several scenes enacted in one print. More often, the figures have to be sought out and can be found lounging on walls, emerging from shadowy corners or nursing a pint, they are well observed, earthy and unsentimental depictions of West Cork life. He records with authentic detail, the rituals of life in a culture that has all but vanished.

previous page: *The Ceremony of Innocence, 2009*
Etching and aquatint, based on an interpretation of WB Yeats' poem 'The Second Coming' for the exhibition 'Yeats and the Golden Age of Print'

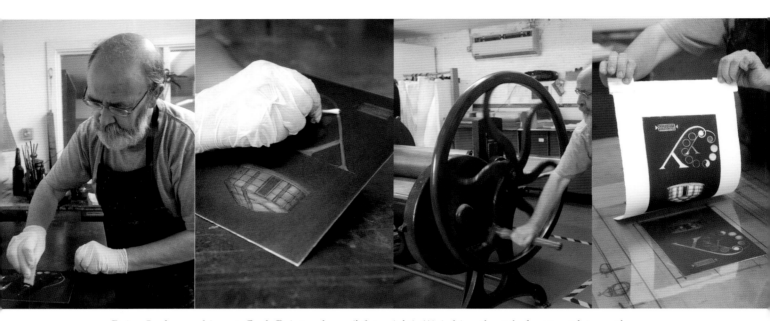

Brian Lalor working at Cork Printmakers: (left to right) (1) inking the etched copper plate on the hotplate, (2) lifting surplus ink from the plate in preparation for printing, (3) rolling the etching press which forces the inked plate and dampened paper together under pressure (4) using paper picks, the finished print which is the reverse image of the copperplate, is lifted from the plate

Brian Lalor was one of the earliest members of the Cork Craftsman's Guild and he exhibited and sold his work through the Guild's shops. He was also enthusiastically involved in the day-to-day running of the co-operative. He regularly attended meetings and contributed his work and artistic eye by organising and running the Craftsman's Guild Gallery and later participating on the selection committee. His etchings and prints often adorned the notice boards and windows of West Cork businesses, advertising exhibitions or inviting people to gallery openings.

Brian Lalor's work can be seen in the print collections of The National Gallery of Ireland, The National Library of Ireland, The Chester Beatty Library and many other public institutions in Ireland and internationally.

next page, top: *A Vision of Glendalough in the Thirteenth Century, etching, aquatint and routetting, 31x65cm, 2007*
right: *West Cork Girl in a Bobbled Hat, etching, aqutint and cutout, 55x36cm, 2008*
far right: *Idyll, etching, aquatint and routetting, 45x30cm, 2008*

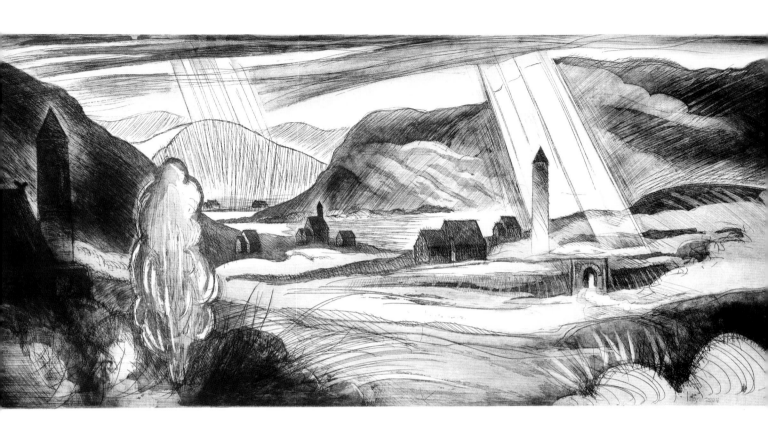

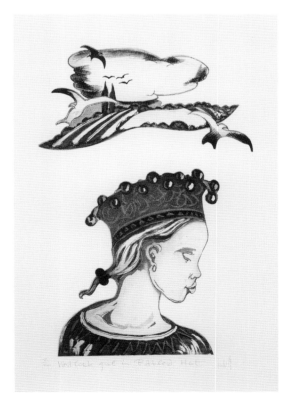

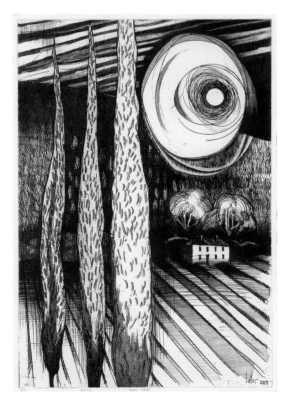

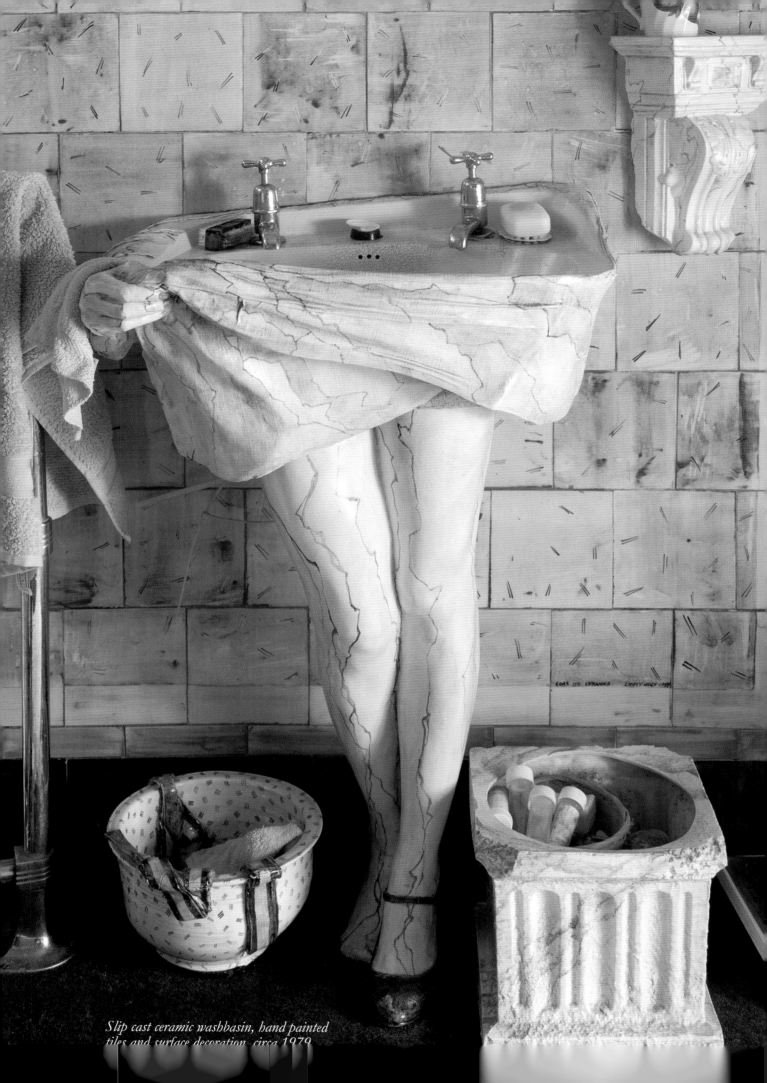

*Slip cast ceramic washbasin, hand painted
tiles and surface decoration, circa 1979*

Ian and Lynne Wright
Sculptors, artists

Our sketch pads were overflowing...we never run out of ideas, just the time to make them.
Ian and Lynne Wright

Ian and Lynne Wright moved to West Cork in 1973, believing they had bought an island in Roaring Water Bay. In fact, they had been swindled by an antiques dealer from England but they fell in love with the area and decided to stay. They spent their first weeks in West Cork living out of the back of their car while looking for a suitable home. Like many who arrived at that time, they had a dream to work as artists and lead lives of rustic seclusion, unsophisticated

but happy. They had been hugely influenced by Rachel Carson's *Silent Spring* and by John Seymour's *Self Sufficiency*, books which describe how to live in harmony with the natural world.

Charlie McCarthy, a local auctioneer, showed them a farm house that was for sale at a reasonably low price. The farmer who owned the house did not believe in banks and sold the house to them on the

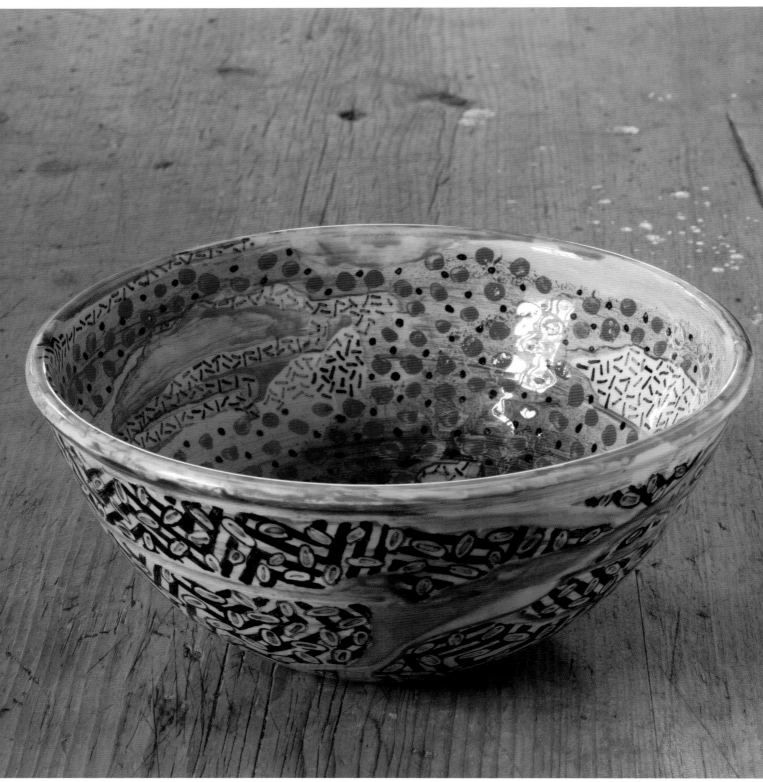

Lynne's handpainted bowl, white earthenware, underglaze painted on bisque, transparent glaze

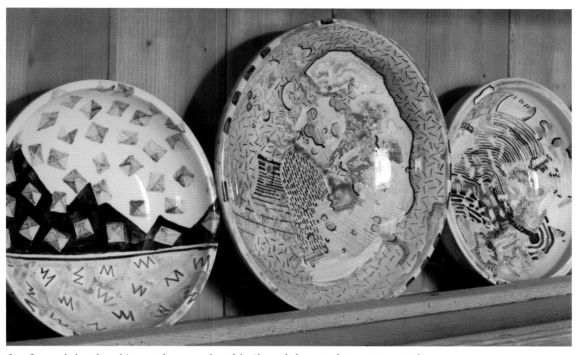

3 x Lynne's bowls, white earthenware hand built and decorated, transparent glaze

understanding they paid him the balance gradually over the next five years. The house needed some repairs and did not have electricity or running water. As they began their self sufficiency life style, their days soon became a round of raising animals, growing vegetables, making cheese, and even killing pigs to make sausages and ham. They lived on virtually no money but were producing their own cream, milk, butter, cheese, meat and vegetables and at certain times of the year were eating a rich, high-calorie diet. Other times of year were hard and local people showed their kindness in a variety of ways. The butcher in Skibbereen, seeing they were hard up, often added a couple of pork chops to a bag of 'scraps for the dog'. Sometimes friends would go out fishing and swap prawns and mackerel for milk and cheese. Almost no one had electricity or fridges, so food didn't keep for more than a day or two.

Ian remembers, 'It was fun for a while but also time consuming and very, very hard work. One day we looked at each other and asked is this the kind of life we really want? And the answer was no'. The self sufficiency life-style did not allow time and energy for artistic work.

Before moving to West Cork, Ian Wright studied Ceramics at the Royal College of Art where he learnt throwing, hand building and mould making. Lynne trained in Fine Art at Winchester College of Art. Their skills were very different but complementary and after college they worked together successfully at making antiques. This work turned out be a great discipline for the pair, reproducing lids to fit antique pots, casting ceramic parts to repair antique lamps etc. They learnt through doing and developed skills in making, decorating and selling. From this

Ian's slip cast ceramic bidet with fluted column soap dish and planter, circa 1980

time, all their ceramic work was designed and made in collaboration, with both contributing ideas for the design of the piece as well as its decoration.

When they first started producing ceramics, they designed and made small, quirky items that were functional but different. Famous amongst these were ceramic containers with lids made by using a flour bag as a mould, ceramic bow ties and egg cups shaped like an egg with its top cut off. They also made earrings and necklaces of ceramic fag ends which proved very popular. At the time silly ceramics such as mugs and teapots with legs and feet were very much in fashion in England but as Ian and Lynne were living in such seclusion, without magazines or

television they were not influenced by what was going on elsewhere. Lynne recalls, 'influences didn't filter through, which turned out to be a good thing, it allowed our imaginations to run free'. Their first exhibition was in the *Cork Craftsman's Guild* shop in Paul Street and was very well received. The show included their notorious flying knickers which were a quirky take on the infamous fifties home decoration fad for hanging flying ducks across the living room wall.

Alongside this work, Lynne has always made and decorated bowls. She refers to them as 'three dimensional paintings'. As she did not train in ceramics or learn to throw, she has become adept at hand building, using moulds. She remains very

Famous 'flying knickers' and fluted column, circa 1980, slip cast ceramic

Ian Wright in his workshop with various 'cement fondue' life-cast statues

much a painter, her work recognisable by her intricately detailed surface–decoration and outstanding use of colour.

Ian and Lynne moved on to designing bathroom fittings. Ian built the moulds, experimented with materials and found a way to make wash hand basins and bidets with legs and feet, beautifully decorated by Lynne's expert brushwork and patterning. Their designs were usually done on paper and continued to develop during the making process. Ian comments, 'I was always frustrated at Art School when we were told what we couldn't do. I like to think that if it can be made by hand I will find a way to do it'. They start with the finished product in mind and work backwards, often having to compromise on what is and is not technically possible. Mould making on that scale is no simple task and Ian's technical ability evolved in response to the demands their imaginations made. Together they played, designed and created pieces that should not really be possible. The resulting work is usually functional, often humorous and technically challenging.

Ian and Lynne supplied the *Cork Craftsman's Guild* shop for many years as well as notable local outlets who were brave enough to stock their work. Eileen Byrne who still owns *Designs* in Skibbereen mounted an exhibition of their early work in her front window to the consternation of many locals. They were also members of the Society of Cork Potters. They took part in exhibitions and attended openings 'for fun and socialising'. In those days it was not unusual for exhibitions to be opened by friends and colleagues who would talk about each other's work. Their unusual work certainly attracted attention and comment. At an exhibition in the famous Gerry Davis Gallery in Capel Street Dublin, a journalist mused 'it definitely isn't art but I have a feeling it is going to last'.

*Tea for Two Teaset in 'Apples' range – teapot, 2 mugs, cream and sugar with tray
Stoneware, blue split, painted slips and sgraffito decoration. Tray size 31cm wide
Production ware, 2009*

Jane Forrester
Potter

I get enormous satisfaction from repetition throwing, with boards of matching pots at the end of the day.
Jane Forrester

Jane Forrester and her husband Robin arrived in West Cork in 1973. They had planned to set up a pottery and painting studio on the Isle of Skye but arrangements had fallen through. One day, while washing the floor at her home in Rochdale, Jane noticed, as she put newspaper down on the wet floor, an advertisement for a craft shop in West Cork with living accommodation above. The property was described in glowing terms and Jane immediately arranged to come over to Ireland. She and Robin were hoping to find a new home where he could paint and she could make pots, in the depths of the wild West Cork countryside. They came with friends and potters Peter and Fran Wolstenholme looking for adventure or at the very least a place where they could afford to buy a house and set up on their own.

Pair of Trinket Boxes with locking lids
Stoneware with manganese and iron slip and sgraffito decoration, 6×9cm, 1979

The premises for sale was *The Flower House,* the craft shop in Ballydehob which had been owned for several years by Christa Reichel. She stocked mostly local handmade crafts including pottery, batik, jewellery and kites. Christa Reichel was waiting to meet them as they disembarked the ferry. Jane recalls 'a large German woman in a kaftan and sandals' who promptly squeezed into their tiny motor car which already had four adults plus luggage, to accompany them on the journey to Ballydehob.

On inspection, the premises did not live up to its description. In fact a bed leg from the room above could be seen poking through the ceiling in the kitchen. Not impressed, 'the Rochdale pioneers' approached Matt O'Sullivan, an auctioneer and estate agent who drove them around West Cork looking for somewhere suitable for four people to live and work in together. A general store in Courtmacsherry caught their eye as it had the added bonus of allowing them to make an income while starting a pottery business in a nearby stone barn.

With growing families and work opportunities, Jane and Robin decided to set up their own separate pottery business and in 1976 they purchased a three-storey townhouse in the centre of Bandon which started life as *The Forresters Gallery* and later became *Bandon Pottery.* Their main products were stoneware mugs, trinket boxes and general tableware. Jane also experimented with different forms and glazes. The work was mostly thrown on a wheel and glazed with earthy neutral tones which were very popular in the 70s. They sold their work through markets and directly from their own shop. Many established potters now remember working for the Forrester's at some stage during that period, throwing pots for minimum wage, gaining skills and experience.

Towards the end of the seventies, Jane applied to join the Cork Craftsmen's Guild which was running a small but fairly successful shop in Cork city. Their work was initially rejected for being 'too slick and professional looking' but on appeal she was accepted as a member. Jane became very actively involved in the day-to-day running of the Guild and was Secretary for several years, until the shops closed in the early 80s. Jane was also a founder member of the Society of Cork Potters and was involved with organising the first potters 'get together' at her premises in Bandon. She was a regular participant in the Society's activities and was actively involved in organising events. She exhibited her work with the group annually at the Crawford Gallery in Cork.

By 1988 *Bandon Pottery* was working to capacity and Jane decided that they would need to invest in more equipment, more space and more staff in order to fill their orders. The pottery had already expanded into the next door property. Above the shop they had a cafe and small gallery selling a variety of different crafts. Jane remembers that they were next door to the courthouse and barristers, solicitors and the accused would pop into the cafe in a hurry during lunch break and adjournments. Customers to the shop were mostly locals

although sales were always better in the summer when tourists also came into the shop.

Jane's description of life at the pottery conjures up a vision of people rushing around a warren of rooms and hallways, upstairs and down the side passage, carrying heavy parcels of raw clay, trays of pots to go in the kiln or others that had just come out. Although *Bandon Pottery* was always very busy and seemed to be successful Jane remembers, 'we never really had any money, the pottery only just paid for itself'. At times their products were very popular and by this time their business depended largely on supplying retailers. It was not always possible to predict how long various styles and designs would continue to be in demand.

During the 80s Jane began to use coloured glazes and developed a very successful range of tableware featuring a bold design of hand painted apples on a deep blue background. This range kept *Bandon Pottery* busy for several years, at the peak of production they were employing 16 people and supplying retail outlets all over the country. This line led to yet another expansion, this time into an industrial unit outside of Bandon with more staff and two extra kilns.

Pieces were thrown at the workshop in Bandon and brought to the industrial unit for firing where there were five kilns doing two firings per week and producing hundreds of items. This level of production continued for a number of years but Jane and Robin found it difficult to run an extra facility away from the main business. Additionally the demand for that particular range started to dwindle and they decided to concentrate things back in their Bandon premises.

In 1998 Jane took the decision to scale back production to focus more on her ceramic work. Her work from the late 60s onwards has incorporated a wide range of materials and techniques such as slip casting, sculpting with thrown elements and slab building. She adds surface decoration by piercing and cutting as well as painting with slips and raku firing. Today, working from a small, purpose-built studio in her garden, she enjoys the complete change of working on her own, with the freedom to make exactly what she wants and producing highly personalised pieces and special commissions.

next page: top left: *Winged Pinch Pot, porcelain with clear glaze and copper stain, 6x10cm, 1983*
top right: *Slotted Vase Form, pit fired crank clay, unglazed, 18x19cm, 1986*
middle left: *Blue Bowl, stoneware with semi-matt cobalt glaze, 12x25cm, 1986*
middle right: *Raku plate with Reclining Nude, crank clay with white slip, stains and sgraffito, 3x20cm, 1983*
right: *Wavy Dish, porcelain with clear glaze and copper stain, 14x17cm, 1984*
far right: *Extra Large plate in 'Forest' range, stoneware with blue slip and waxed spiral ,decoration on rim, light tan glaze, 4x35cm. Production ware, 2009*

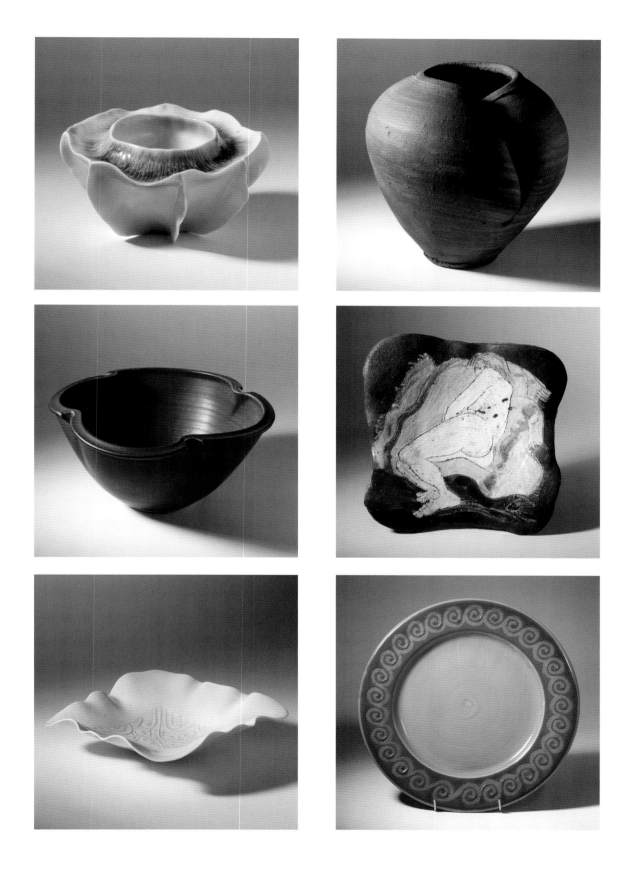

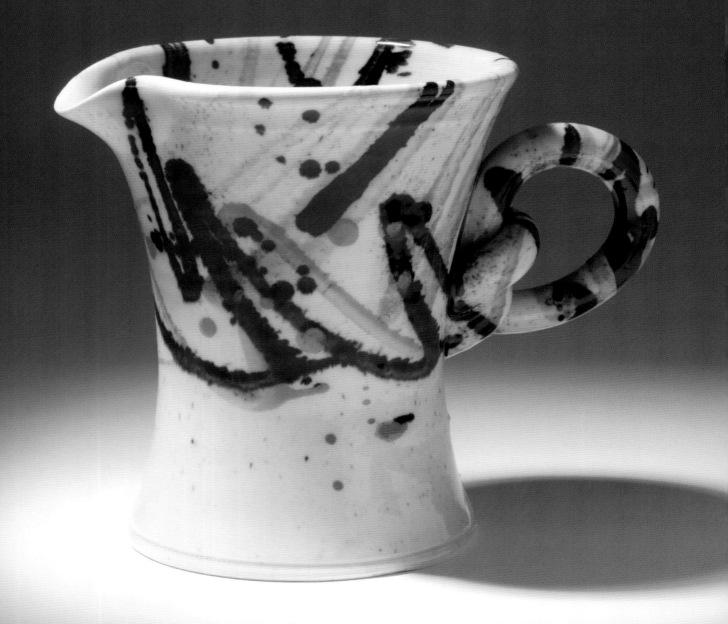

Porcelain Jug
srynge decorated, 13cm high, 1990

Peter Wolstenholme
Ceramic artist

*My ceramics are about my life in, and
love of, West Cork.*
Peter Wostenholme

Peter Wostenholme and his wife Frances
came to West Cork in 1973 with his
colleague Robin Forrester and his wife Jane.
Peter and Robin were both teachers at
Rochdale Art College and shared a vision
to leave their safe, pensionable lecturing
jobs and look for adventure and an artist's
life elsewhere.

As detailed by Jane Forrester, they were met
at the ferry port by Christa Reichel who had
a 'craft shop with courtyard and
accommodation' for sale, which at £3,000
seemed like a bargain. Peter recalls viewing
the building and realising very quickly that
it was riddled with woodworm and would
not last in its present condition for very
long. In fact they were later told the story
of how the entire first floor of the building
next door, had collapsed under the weight
of a party crowd soon after.

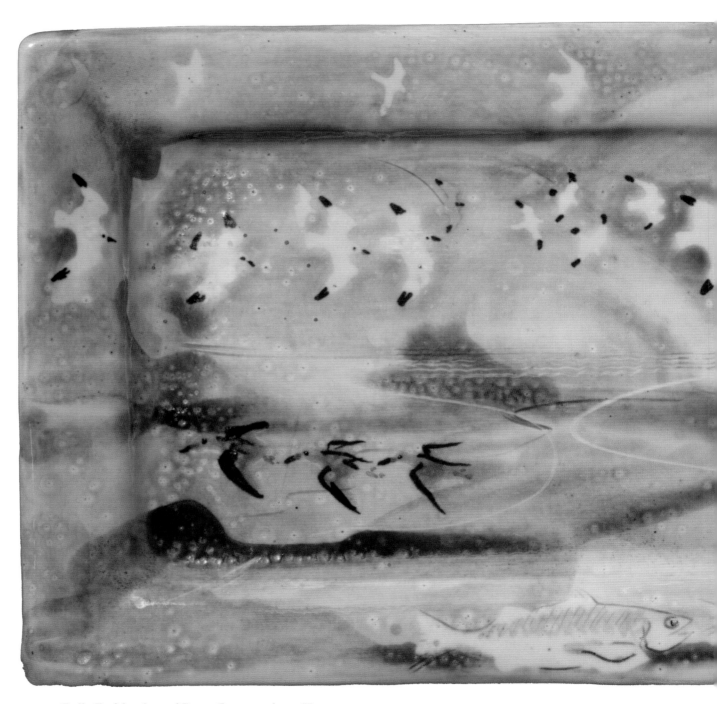

Gulls, Redshanks and Bass, Courtmascherry Estuary
porcelain plate with mother of pearl, 1995

As they had come for the June bank holiday, the four, who were immediately drawn to West Cork, decided to spend the rest of the long weekend looking around at what else might be available. Matt O'Sullivan, a local auctioneer, took them to view various properties and eventually they decided to purchase a small general store in Courtmacsherry which would allow them to make some income whilst setting up their pottery business. The store came with a convenient stone shed which was suitable for turning into a pottery studio. Together they ran the general stores for four years, at which point, as they both had growing families, the two couples decided to go their separate ways.

Peter and Frances bought a house in Courtmacsherry and received an Industrial Development Agency grant to develop a pottery at the back of the premises and a small shop in front. They were making miniature pottery sheep and goats which were a very successful wholesale line. Bord Fáilte played a key role in helping to establish trade business, through their craft showroom in Ireland House, Stephen's Green, Dublin. Blanaid Reddin was responsible for the Bord Fáilte craft sector and ran the trade showroom for many years. She would visit West Cork two or three times per year, sourcing new products and offering financial support to the small businesses requiring help.

Within a short time of establishing the studio, the order books were full. A large amount of their work was exported and they accessed the important American market through a mail order catalogue run during the 1980s by Carroll's cigarettes manufacturers in Dublin. Peter developed a

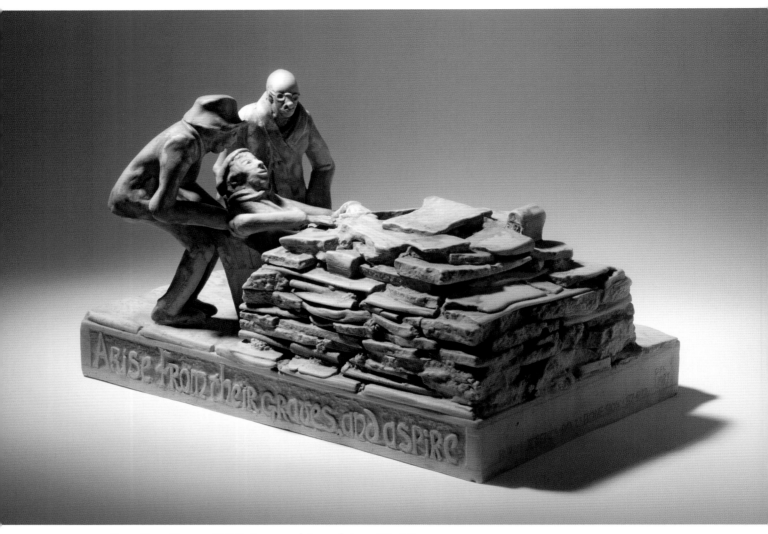

Bone Box, Burren IV Series, porcelain sculpture, 25x19cm

new range of tableware that was also well received. At the peak of their production, *Courtmacsherry Pottery* supplied forty shops, some of them in Ireland, others in Germany and the United Kingdom. Once his work had been accepted for sale in the *Cork Craftsmen's Guild* shop in Cork, Peter became very involved in the running of the co-operative and worked on behalf of the Guild for many years. He was also a very active member of the Society of Cork Potters.

In 1980 Peter was funded by the Irish Development Agency to represent Ireland at the World Crafts Council Annual Congress in Bornholm, Denmark. Peter attended many of the workshops organised for the delegates, aimed at encouraging craftspeople to network and share information. On his return, he suggested to the Industrial Development Agency that funds might be better utilised bringing internationally renowned master craftsmen to run similar week-long seminars in

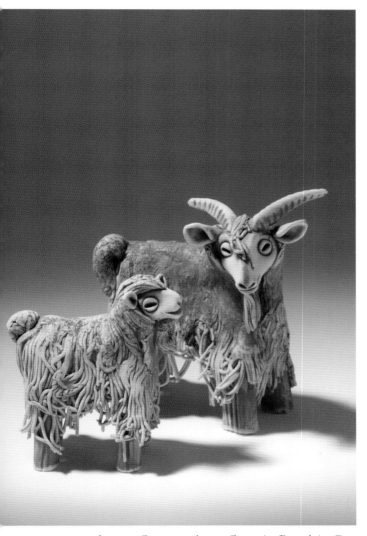

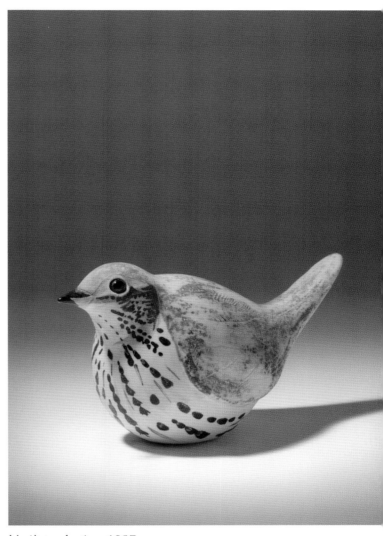

above: *Courtmacsherry Ceramics Porcelain Goats, hand built production, 1987*
right: *Song Thrush, slip cast and hand painted porcelain sculpture, 12.5cm long, 2002*

Ireland. This idea was embraced and for several years, the Cork Potters Society invited accomplished ceramic artists to West Cork to demonstrate, teach and work with the potters. Ceramic artists were invited from all over the country to attend these sessions which proved to be very exciting and instrumental in developing new techniques in making, firing and decorating.

Peter continues to produces wonderful tableware decorated with landscape and wildlife motifs. He also makes gold lustred and glazed trophy pieces for special occasions which are only available from *Courtmacsherry Pottery.*

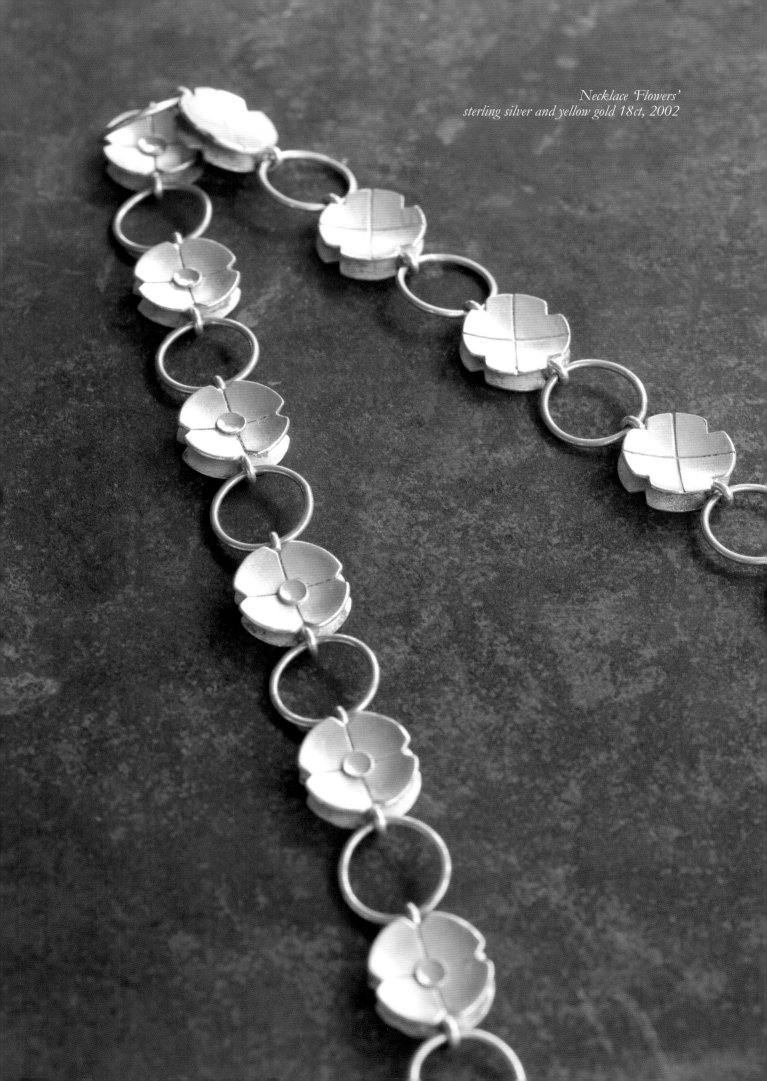

Necklace 'Flowers'
sterling silver and yellow gold 18ct, 2002

Gert Besner
Master goldsmith, designer, artist

Nature is the best inspiration, whatever field you work in.
Gert Besner

Gert Besner left school in Germany at the age of fourteen and began an apprenticeship with a blacksmith. He completed his training but quickly realised that although he enjoyed the alchemy of working with metal, this was not the right career for him. He then apprenticed himself to a watch maker, working metal on a completely different scale. This training was to last a further three and a half years. He found the work interesting but as digital technology was sweeping the market, he realised a watch maker would soon become just a repairer of old watches, which did not appeal to his creative bent. Next to the watchmakers, Gert had noticed a goldsmith working and so, having taken two years to do his national service in the army, at the age of twenty three, he embarked on a goldsmith course at the Cologne Art School.

His attraction to goldsmithing was motivated by his desire to produce beautiful, wearable jewellery whilst retaining control over the whole process. To Gert, it is the process that connects the skilled goldsmith of today with artisans of the past, working with the same principles, raw materials and tools. He studied industrial design in order to develop his capacities to the highest possible level.

In 1973, Gert set up his first workshop in Cologne whilst studying for a Masters degree at evening classes. In Germany goldsmiths must hold a Masters degree because they are dealing with precious materials. The MA course teaches 'stamping' which is essential as goldsmiths are responsible for guaranteeing the quality of the metals and can face a twenty year prison sentence for dishonest practices.

Ring, sterling silver, aquamarine crystal, 2010

Although brought up in an urban environment, Gert had travelled widely during his apprenticeship and longed to settle and work in the countryside. In the summer of 1978, he arrived by ferry at the port of Rosslare with a bicycle and backpack, on his way to visit some artist friends living in a caravan near Baltimore. After travelling the south of Ireland from coast to coast on his bicycle, he arrived in West Cork, for a month-long stay. The gently undulating landscape made an immediate impression on Gert and throughout the following month of unbroken sunshine, he resolved to try and find a small place to live in the area. A chance acquaintance directed him to a three-quarter acre site with a dilapidated

Bangle, yellow gold 22ct, sterling silver and ivory, 1980

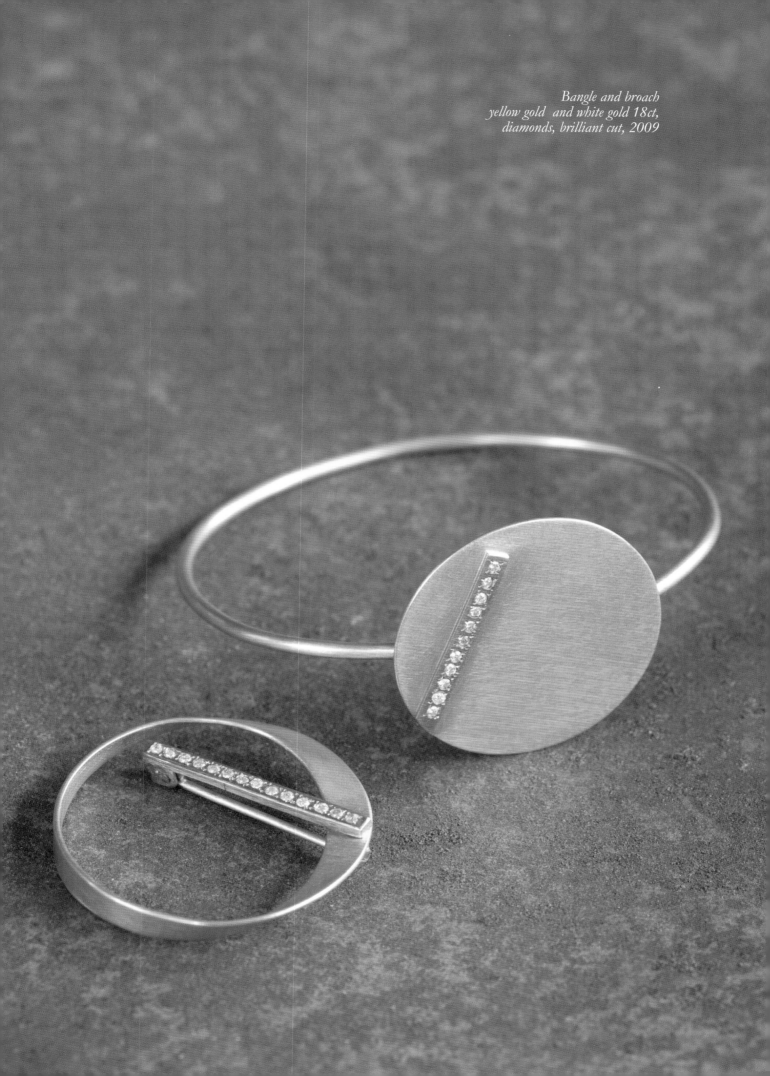

*Bangle and broach
yellow gold and white gold 18ct,
diamonds, brilliant cut, 2009*

Pillbox
Sterling silver, marble, 2002

cottage near Skibbereen. The following summers were spent repairing and renovating the house with help from friends and neighbours.

For the next twenty years, Gert divided his life between one home and workshop in Germany and another in West Cork. He learnt to travel light, moving a basic set of tools back and forth with him. The challenge was to become highly skilled with the few simple tools that he had designed and made himself. Gert consciously modelled his work practices on those used in ancient times honing his skills through the challenge of working with limited resources. To this day, he does not buy standard tools as he feels that the resulting work could also be 'standard'. He believes that the processes, time and skill that create each piece, make the finished work more precious.

Gert's inspiration comes from many different sources including the natural world. New ideas come to him in sudden flashes, especially when not working under commercial pressures. He likes to work with a variety of materials, and refuses to be limited by lack of skills. Learning new techniques has been a life-long goal and he has taught himself to work with enamels and other metals, continuing to push the limits and create ever more challenging work.

Gert was influenced during his early apprenticeship experiences in Cologne – a city noted for the profusion of artisans based there since the building of its

cathedral in the thirteenth century. His professor at the Cologne Art School had worked for several years on renovations to bejewelled Byzantine icons in the cathedral. Gert has experience of working gold by casting but feels a connection to history when he is beating and hammering metal, the same processes and tools used to create the ancient artefacts which inspire him. 'Beating and hammering make the metal stronger and give it tension, making it more long lasting and more beautiful.'

Gert Besner's work is unique in this region and he makes jewellery that one might expect to see in an exclusive London or Paris boutique. He brought skills and training from Germany, found inspiration in West Cork and made the tools that leave the mark of his human hand on his stunning pieces.

Bangle 'Infiniy'
yellow gold 18ct, sterling silver, 2005

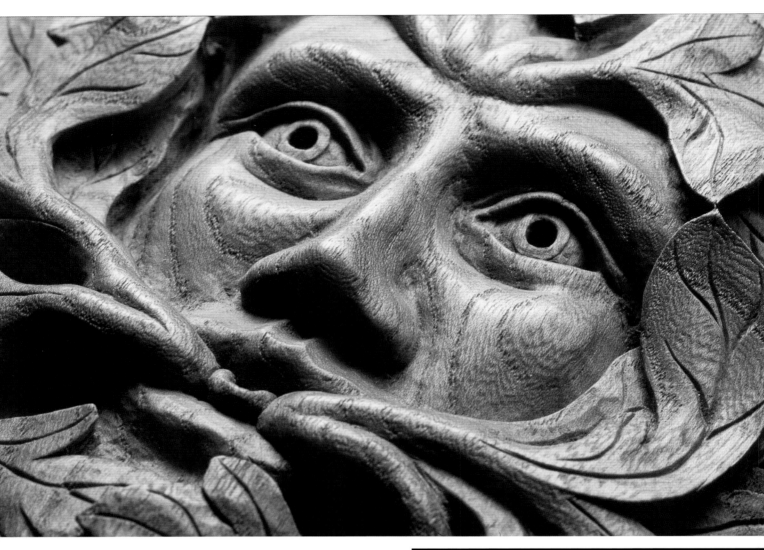

Green Man
Elm, 19cm
photographed by Ben Russell

Ben Russell
Woodcarver, architectural woodworker

I love the characteristics of different timbers, the colours and grain patterns, and the distinctive smells when you're working them.
Ben Russell

Ben Russell and his wife Joyce moved from England to West Cork in 1978 seeking a simple, more natural lifestyle in an unspoilt environment. They house-sat a property near Kealkil, Bantry for six months and then decided to stay a little longer. They lived without electricity or running water, reading by candlelight and cooking on a range. For the first three years Ben worked on repairing the house in lieu of rent. A motor cycle and side car served them for transport purposes and a donkey and cart for use on the land. Ben and Joyce embraced the self sufficiency lifestyle, keeping livestock, growing their own food and sharing skills and resources with their neighbours.

Ben came from a creative background and had attended Bedales School, an independent school with its roots in the Arts and Crafts movement of the late 19th

century. One of the school's stated aims is 'to foster individuality and encourage initiative, creativity and appreciation of the beautiful'. Its magnificent cruck frame library and furnishings by Edward Barnsley exemplifies the school's ethos. Barnsley was one of the most important furniture makers in Britain during the 20th century. Inspired by William Morris and his radical ideas he built his own house in the Cotswolds using local materials and traditional techniques. He established a furniture workshop working with solid hard woods and celebrating the construction methods by exposing the tenons and dovetails in his joints. Ben admired Barnsley and visited his Froxfield Workshop in Hampshire recalling that 'it was the first time I remember being really excited by wood: the yew and elm he had used in a Windsor chair and simple oak bookshelves he had in his cottage. All very natural and respectful of the material'.

After leaving school, Ben continued to be an inquisitive thinker, constantly watching, absorbing information and learning new techniques. His guiding principle has always been 'if it can be done by hand, I can probably do it'. Spending time on the Isle of Man with inspirational teacher, sculptor and carver David Gilbert, instilled in Ben a yearning to produce his own creative work and the ambition to excel at a traditional craft.

During his first years in West Cork, Ben gained valuable experience by working as a community carpenter, undertaking a range of work from house carpentry to handmade joinery and wooden wheel repair. He profoundly enjoyed working with tools and relished a challenge, deciding early

Altar – detail of carved capital,
Holy Trinity Church, Cork

Centrepiece carving on ambo oak, walnut
Holy Trinity Church, Cork

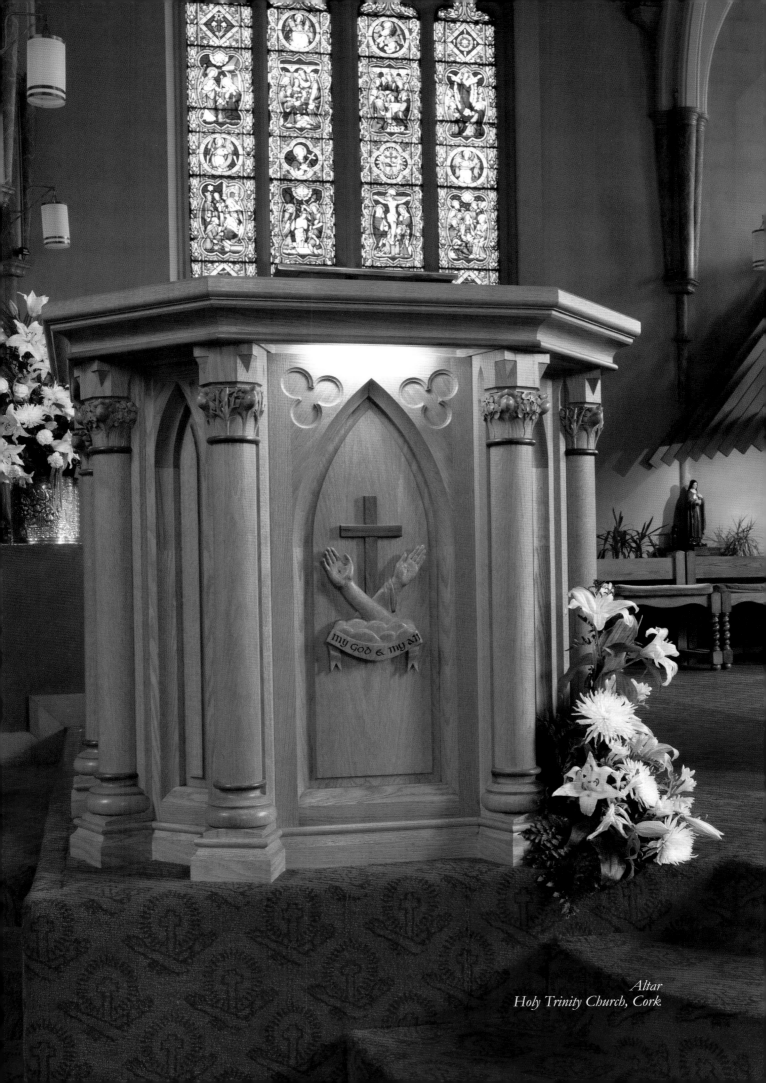

Altar
Holy Trinity Church, Cork

on that the best way to learn was 'to accept the job and work out how to do it afterwards'. Alongside the carpentry and joinery work, he practiced and developed his carving skills, gradually accumulating the knowledge and expertise needed to undertake almost any woodwork technique. Bantry Library was an important resource for learning and Ben remembers finding a wealth of useful information on woodwork from the many books he borrowed.

He began tentatively carving letters on signs and adding decorative detail to doors and furniture discovering he had a good eye and enough patience to do precise and careful work. Cutting letters into wood presented Ben with a sense of discipline that appealed to his meticulous approach. He found these early attempts at carving both inspiring and satisfying and felt it was a medium through which he could express imaginative notions and ideas. Many of his early pieces were a response to needing things in the home. 'Joyce wanted a ladle, so I sketched my own hand and began to carve. I love the interface between imagination and practicality.'

Although woodcarvers are not easy to find in West Cork, The Crawford College of Art has a long tradition of teaching furniture making and woodcarving to both tradesmen and artists. Joseph Higgins (1885–1925) and Seamus Murphy (1907-1975) are Cork's two most significant sculptors of the 20th century and both attended sculpture and carving classes at Crawford. Decorative wood carving can be found in most of the local churches in the region and yet little is known of the craftsmen who carried out the work.

During the 70s there were very few native crafts being made in West Cork. Bantry town supported one or two farriers and a saddle and shoe repairers but the handmade work was of an exclusively practical nature. Ben found himself in a unique situation for learning new skills and developing a reputation for high quality work. For several years he perfected his woodwork techniques and produced carved work and joinery of a high standard, yet was not in a position to compare his work with anything similar. He thought of himself primarily as a builder and furniture maker, it would be many years before he considered himself to be a craftsman.

David Rose, a well known figure in West Cork, who took 'craft out of the craft shop and into the art gallery' admired the hand

An Leath Phingin – old half-penny coin
Waney edged oak, 40x40cm

carved sign that Ben was making for a restaurant in Kenmare (*An Leath Phingin*) and complimented him on the high standard of craftsmanship which was 'excellent and of exhibition quality'. It was only then that Ben began to recognise the quality of his own work as Rose was an enthusiastic art collector and organised art events with his Dutch partner Tanya. (Tanya, in a typical display of West Cork wit, was known affectionately as 'the Dutchess'.)

Fortunately there is now a growing interest in the preservation of traditional carving skills and enough discerning customers who recognise work that has been created with passion (unlike the computer programmes and sand blasting techniques that allow unskilled operatives to produce perfect lettering at high speed). In recent years Ben has been commissioned to carve the coat of arms for the College of Anaesthetists, Merrion Square Dublin and using entirely Irish-grown wood and wood products he furnished the offices for the Council for Forest Research and Development on the University College Dublin campus.

Ben's Russell's work, including both three-dimensional pieces and relief carving demonstrates his tremendous personal qualities of initiative and creativity. His love of learning has driven him to devote his working life to perfecting his creative skills and an ethic of craftsmanship which can be seen in his work and in his lifestyle.

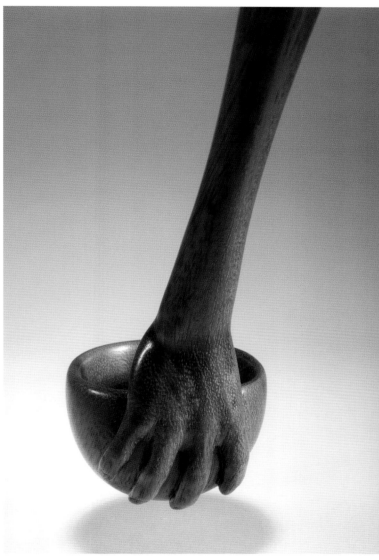

Carved ladle, from a scrap of Iroko

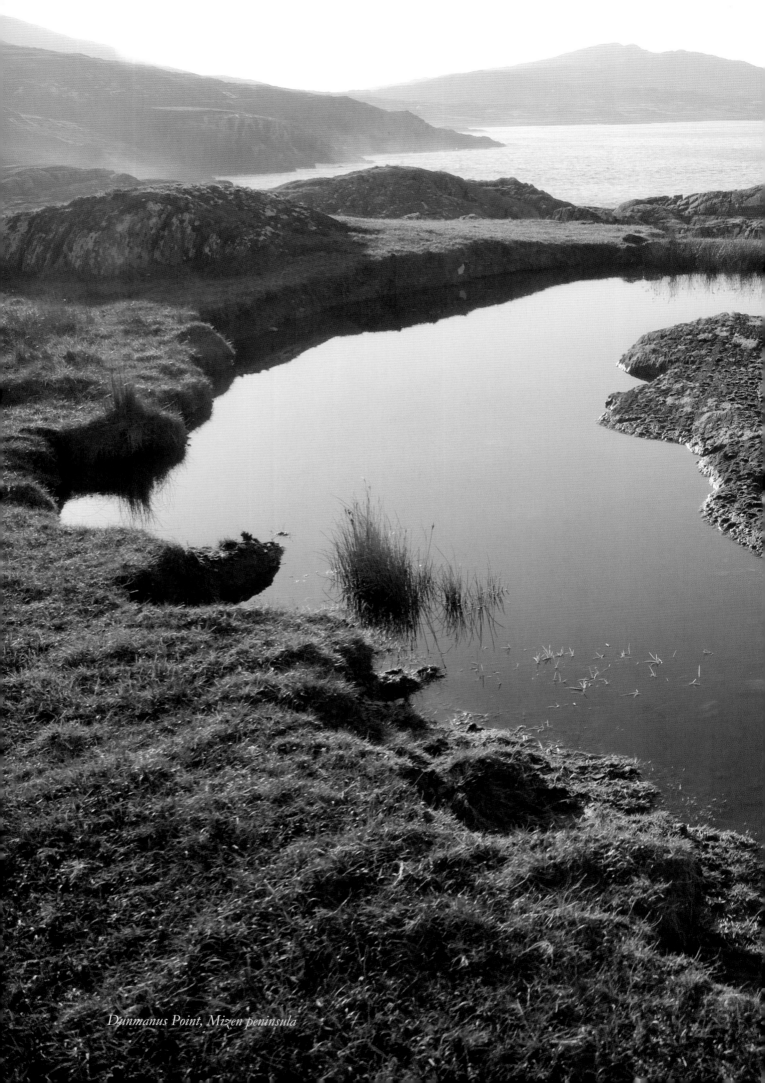

Dunmanus Point, Mizen peninsula

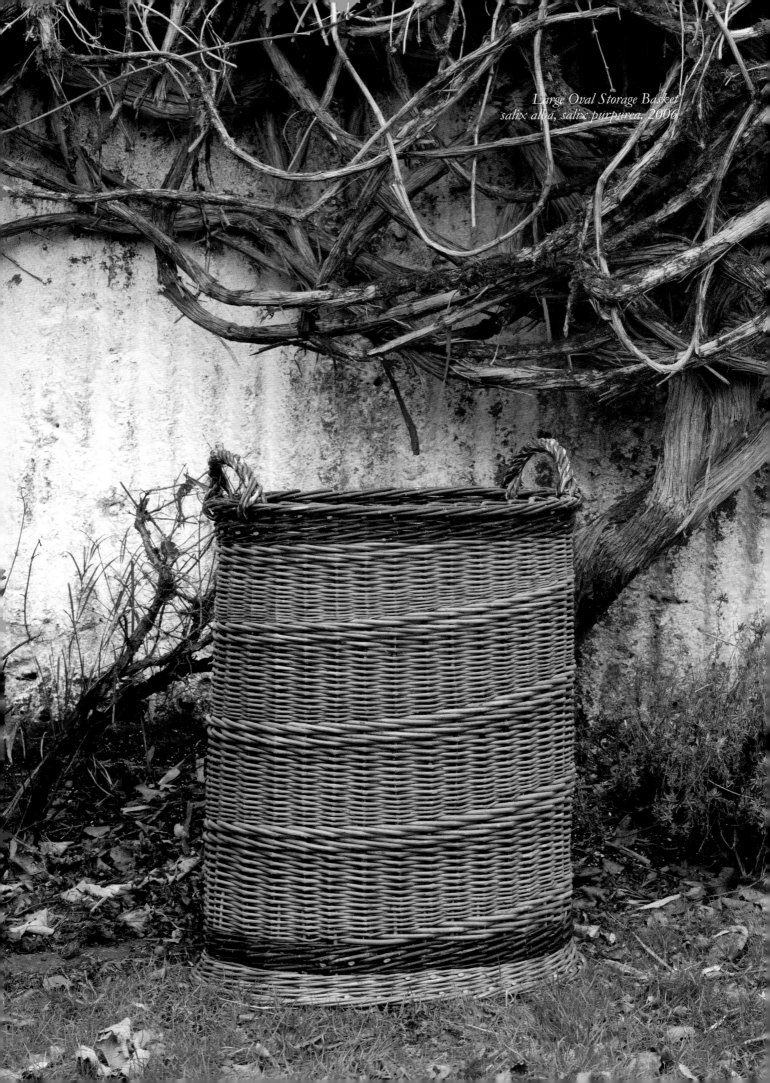

Large Oval Storage Basket
salix alba, salix purpurea, 2006

Norbert Platz
Basketmaker

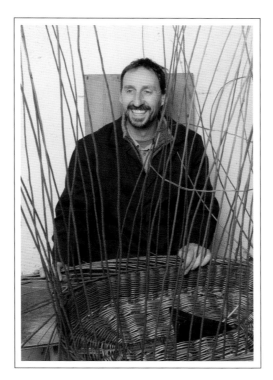

My mother commented, 'You remind me of my grandfather, he used to gather baskets up in the winter and repair them for all his neighbours'. Until that moment I did not know that my grandfather had also grown willow to make and repair baskets.
Norbert Platz

In the early 1980s Norbert Platz left behind his life and work in Germany and joined a spiritual community based near Timoleague in West Cork. The community had its roots in San Francisco and had chosen West Cork, with its remote, secluded countryside, as an ideal location for a European retreat. Four or five families made up the group of twenty five to thirty people although numbers were often increased by visits from itinerant 'hippies and drop outs as well as Greenpeace activists who were looking for somewhere to rest and recuperate.'

During the 1960s and 70s communes could be found almost anywhere in Europe and

the United States. This particular spiritual community had connections with groups such as Findhorn in Scotland and L'Arche in France. The spiritual side of life was very informal and seems to have included elements of Buddhism along with a variety of mind-expanding experiences which were popular during that time. The community lived in Lettercollum House, a large rambling manor house, rent-free with the usual arrangement of keeping the place in good condition and looking after the roof.

Once he arrived in West Cork, Norbert's training as a fitter and his experience of working in heavy industry allowed him to adapt his skills into building, repairs and renovation. He had grown up in the German countryside where his boyhood had been spent making bows and arrows and building dens. He had always made things and felt very much at home working in the building trade. 'I always had an interest in vernacular building and there was

plenty of renovation work happening in West Cork. I especially enjoyed repairing old thatched cottages.'

During the recession of the mid-1980s building work became very scarce. One of the tenets of the spiritual community was 'do whatever you can to support yourself'. Norbert wanted to find work and avoid receiving benefits. Having heard from artist friends about the Cork Craftsman's Guild, he visited The Savoy Centre, Patrick Street in Cork where he met the manager, Christine MacDonald. She was finding it difficult to source good quality baskets because the older basketmakers were retiring and very few young people were interested in learning the skills.

Basketmaking was essentially a rural industry which declined after the Second World War when cardboard boxes and plastic bags came into common usage. However, a small industry did exist in Ireland at the time. The Quinlan brothers

French randing on Moses basket, salix triandra, 2009

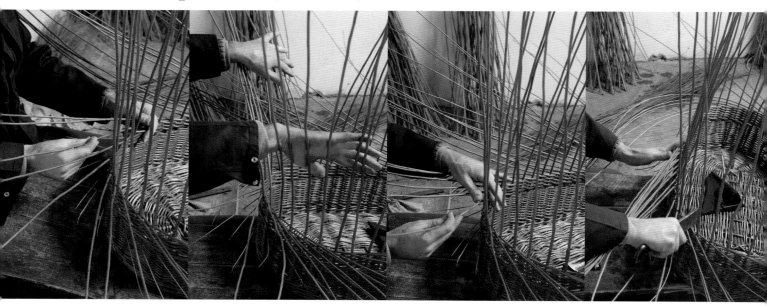

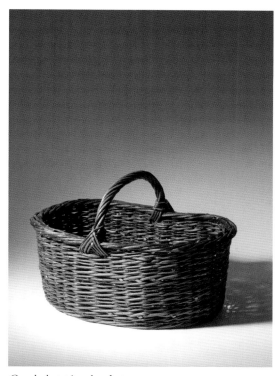

Oval shopping basket
salix purpurea, salix alba, 2009

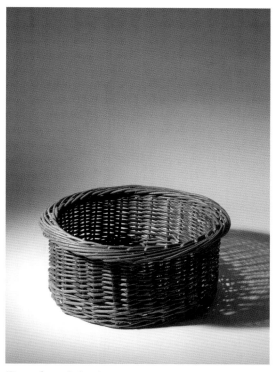

Round apple basket
salix purpurea, salix alba, 2009

based in Tallow, Co. Waterford had good local trade and sold work as far away as Cork and Wexford. They also supplied *The Country Shop* in Dublin. The Shanahan brothers, Joe and Mikie, in Carrick-on-Suir were both full time basketmakers and during the early 1980s they trained a small number of apprentices.

At around the same time, Mike Collard who now runs the *Future Forests* nursery and garden centre had begun to take an interest in basketmaking and was being taught how to make hazel baskets by a retired local maker who was happy to pass on his considerable skills. Norbert, like Mike was simply looking for a way to make a living and basketmaking appealed, partly because

it required little investment in terms of materials (you can grow your own willow) and both believed they could learn the necessary making skills. Once he had made the decision to learn, Norbert spent a weekend with Mike Curtis near Dunmanway who was an experienced basketmaker from the UK. He recalls, 'just the smell of the willows and the ambience of the shed were enough to get me hooked'.

Once he had mastered the skills of basketmaking and developed confidence in his work, Norbert began taking stalls in local markets and at the myriad of craft shows/fairs which started to appear towards the end of the 1980s. He also

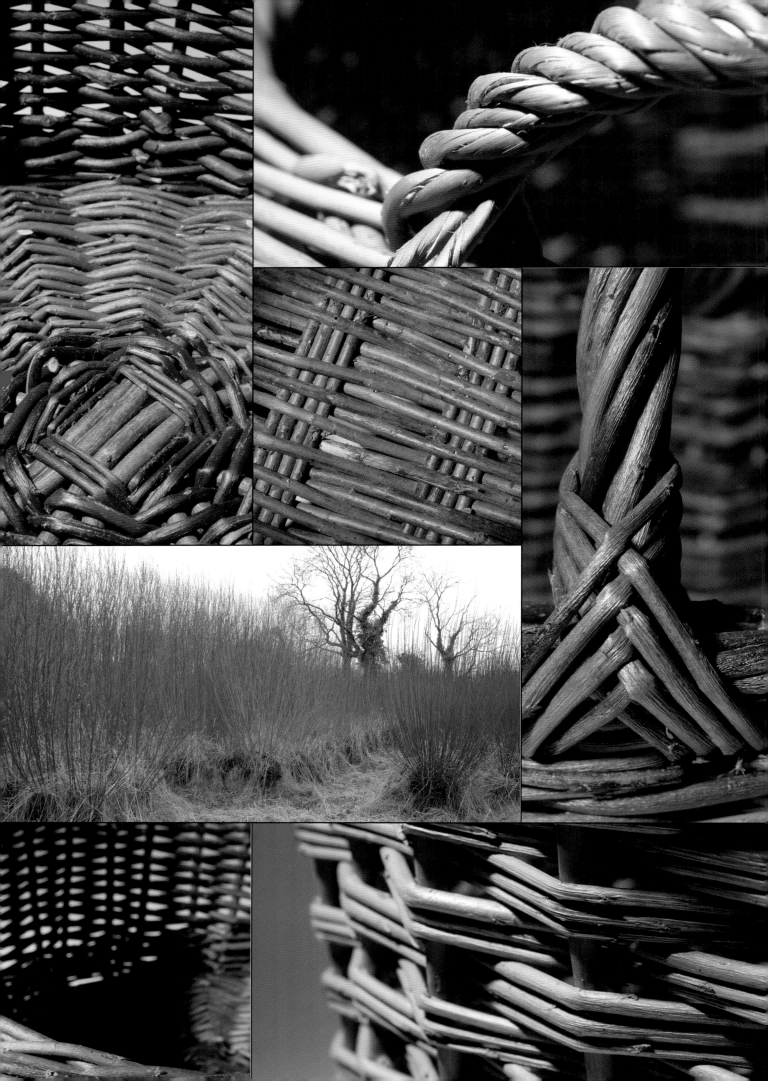

travelled when the opportunities arose. 'I would stack the baskets into my old VW Beetle and drive as far north as Galway to attend popular markets. One day I sold an entire car full of baskets without even unpacking them.'

A problem that has dogged basket makers for decades is the number of cheap imported baskets coming from Eastern Europe and more recently from China. However, Norbert recalls making a niche for himself and working the system in his favour. 'I learned a lot from the foreign baskets. I made contact with someone who sold cheap imported baskets, soft furnishings and household items and asked if they might stock my work. The shop owner said if I could make the baskets for the same price as he paid for the imported ones then we could do business.' Norbert went home and literally took one of the imported baskets apart to figure out how it was made. With Dorothy Wright's *The Complete Book Of Baskets And Basketry* at his side he began producing and selling baskets that did indeed compete with the imported work.

In the past, basketmaking was often done on the farm. It was a job for the winter months when farmers would make their own donkey creels (panniers). According to Norbert, in many cases they might have learned how to make one single style of useful basket and would repair and renew as necessary. They would be unlikely to have the skills to adapt the style to making a cradle or shopping basket. Norbert once had an old basket in for repair that had clearly been patched up many times before with bits of wire and twine. 'Baskets fulfilled a function, it did not matter if they were rough and not especially well-finished, the important thing was that they worked.' This led him to question the current obsession with design and innovation that grips the craft world. 'Years ago the work was rugged and rough, there was an honesty about it....these days our work is becoming ornamental rather than functional and I feel we have lost something because of it.'

Norbert enjoys living the life of a traditional basketmaker and he loves the West Cork countryside. 'I am a visual person and I get sustenance from it', and he enjoys being part of it, growing his own willow and selling to local markets. 'It is a bit like the slow food ethos, you grow your own materials, work from home and sell your products within your own region.' There is a very real physical connection between his environment and the work he produces. His materials are part of West Cork, the willows grow here, their earthy colours are formed in the soil and the resulting baskets reflect the gentle forms and shades of the landscape around him.

previous page: *Collage of weaving techniques; and willows, ready for harvesting*

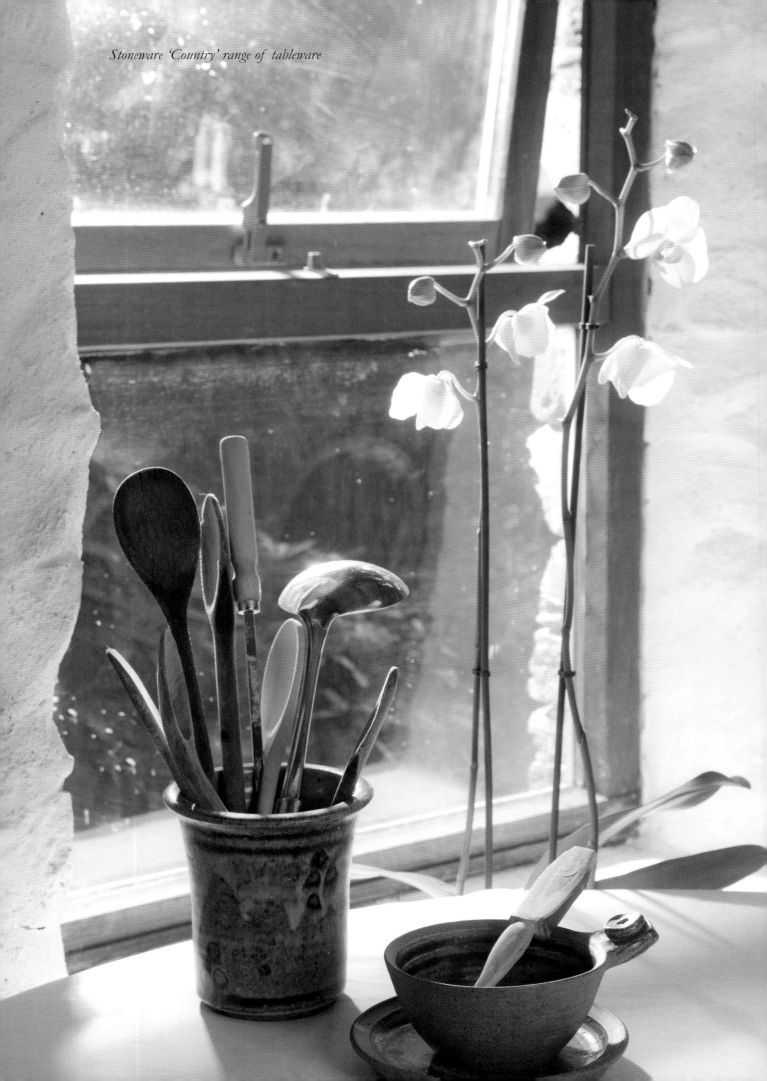

Stoneware 'Country' range of tableware

Jim Turner and Etain Hickey
Ceramic artists

It was sink or swim for people setting up here, we were challenging ourselves to make things work.
Jim Turner

Etain Hickey and Jim Turner have worked together for over 25 years producing a wide range of ceramic products from plant and chimney pots to fine tableware and highly accomplished art pieces.

Together they have designed and made various ranges of oven and tableware, collaborating at all stages of the process. They each have the capacity to produce large quantities of thrown items in a day or indeed carry out any part of the production process, but the surface decoration is usually the accomplished work of Etain and the kiln is fired by Jim.

Jim Turner was brought up on a smallholding in Dorset. His father Roger had been invalided out of the British Army in the 1940s and subsequently trained as a potter at Farnham College of Arts in Surrey. He made a living by making slip-

trailed earthenware items which he sold from his workshop in Cheselbourne. In 1958, Roger Turner helped set up the Craft Potters Association of Great Britain. The Association, which still exists today, was formed as a co-operative to sell the work of its members and to increase public awareness of contemporary studio pottery.

When Jim embarked on an Arts Foundation Course at Kingston College of Art in 1967 he was considering a career in architecture. In 1969 he transferred to Camberwell College of Art from where he eventually graduated in 1974 (Roger Turner has become ill during this time and Jim took time out to work at the family pottery). Jim soon became adept at throwing on the wheel and decorating using coloured slips, and also helped to expand the business, employing several local people.

Etain Hickey is from Dublin and graduated from Dun Laoghaire School of Art with a Diploma in Fine Art in 1975. Although the course focussed mainly on drawing and painting, Etain also acquired basic pottery making skills. At the time there were very few ceramic artists or producers in Ireland and after graduation Etain was obliged to look abroad for opportunities to improve and extend her skills. She consulted a booklet (produced by the Craft Potters Association of Great Britain) listing work placements and training opportunities available in the UK. Attracted by the island location, she applied for and secured a position in a pottery on the island of Alderney.

Etain and Jim met when they both started working in Peter Arnold's pottery in the Channel Islands. Peter was a friend of Jim's father who had set up a pottery at his home in Alderney and offered employment to young graduates and potters wanting to improve their skills. They were paid £5 per week and were encouraged to experiment with their own designs and glazes, making 'whatever they wanted' as long as it would sell and create some income for the business. This was valuable experience for them both and an opportunity to gain insights into production, decoration and running a business.

It was during their time on Alderney that Etain and Jim conceived the plan to set up a pottery of their own. Etain was familiar with the beautiful landscapes of West Cork and knew that property was inexpensive and empty houses relatively easy to find. In 1976 they put down a deposit on a derelict farmhouse in West Cork but were to spend the next four years awaiting the results of a legal wrangle over the deeds. They spent the interim years working, saving money and developing their skills and experience in a variety of pottery studios.

In 1980 Etain and Jim moved into a caravan on the site of their house near Rossmore, West Cork. At first they had no access to running water or electricity which meant collecting water from the village pump every day. Jim applied himself to repairing the building and before long they were able to move in to the shell of a house, albeit

next page, top left: *Slip trailed earthenware plate, Etain Hickey*
top right: *Mini trophies, dry glazed stoneware, Jim Turner*
left jug: *Slip trailed decorated stoneware jug, 25cm high, Etain Hickey*
right jug: *Salt glazed jug, 30cm high, Jim Turner*

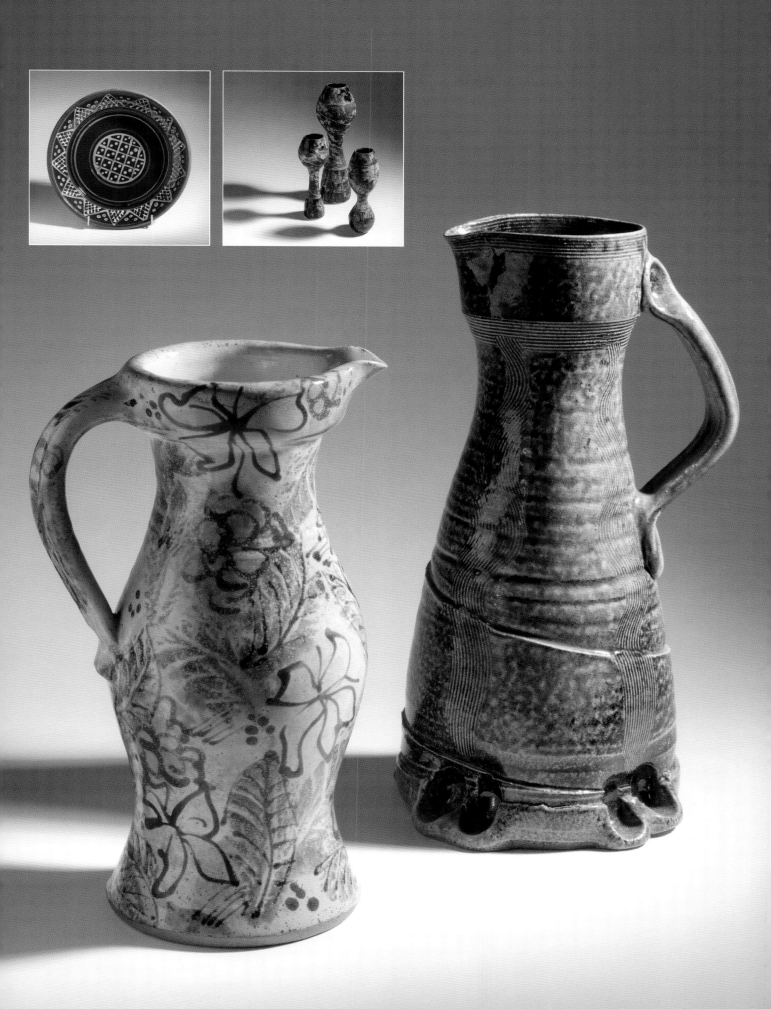

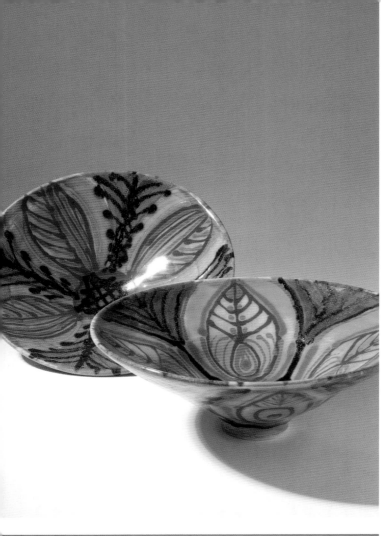

with concrete floors and a plastic sheet to keep the rain out. Despite the frugal living conditions, they were pleased to find that West Cork was a relaxed and friendly place to live and that a number of potters were already living and working in the region

By the mid 1980s both Etain and Jim were experienced in a range of production and decorative methods. Working with a multi-fuel kiln, their first products were red earthenware flower and strawberry pots and chimney stacks, which they sold to local hardware shops. At that time, there was a sudden explosion of craft shops opening in the towns and villages of West Cork and for several years they supplied their work wholesale to craft shops in Skibbereen, Leap, Golleen, Clonakilty and Bantry. Introducing more variety to their product line, Etain and Jim designed a range of oven and tableware incorporating the earthy colours which were fashionable at the time, decorated with a trailed blue slip. Etain recalls, 'we were always busy, it was a good time to be a potter'.

They became members of the Society of Cork Potters and were soon enthusiastic participants in all of their activities and events. They especially enjoyed the feeling of solidarity and community amongst the group's members and their ethos of sharing knowledge and expertise. As they became more involved in the running of the Society, Etain and Jim also began to develop their own individual artistic work for showing in the annual exhibition at the Crawford Gallery. Once a year they took time off from the hard grind of production to spend time in the

top: *Etain's West Cork Garden Stoneware slip trailed bowls, 25cm wide*
left: *Flapper!, stoneware paperclay with gold lustre*

workshop exploring and experimenting with their materials, each creating their own very individual body of work.

As individual artists, their work has developed very differently. Etain employs a variety of techniques to apply drawn figures and other decorative motifs to her bowls using a paintbrush or shaped sponges and coloured slips. Her free flowing brushwork belies the skill involved in creating the bold and colourful designs which have come to characterise her work. These are difficult materials to work with, yet each highly decorated bowl is something of a painting in itself and her expressive brush strokes appear to have been effortless.

Etain's artistic style continues to evolve with her use of intricate patterning and lavish gold lustre. Adding to her core skill of producing classic forms thrown on the wheel, Etain is exploring the use of paper clay in creating three-dimensional sculpted heads. These pieces are highly original with surface decoration that is reminiscent of the paintings of Gustav Klimt or illuminations in the *Book of Kells* – purportedly influenced by Coptic, Islamic and Jewish manuscripts. The bowls are decorated with complex geometrical patterns in gold lustre combined with coloured slips and glazes. Her women's heads with sumptuous and elaborate headdresses radiate the subtle grace and dignity of a Japanese geisha or the power of a Hindu goddess.

Jim Turner is an exceptionally capable craftsman and artist, open and receptive to

top: *Fafoo with feathers, head paperclay with slip trail decoration and lustre, 33cm high*
right: *4 Tapersty decorated Bowls, stoneware with lustres, widest 38cm*

his unconscious inspirations, allowing them to drive his work. Watching him at work is somewhat like watching his 'inner child' at play, his unfettered enjoyment, his hands feeling and exploring the clay, using any available tool to add texture or form. He is clearly and literally in his element. Anything is possible in Jim's workshop as he is constantly making, designing and constructing new work. It evolves at the bench, often through the actual construction process, it is by improvisation and exploration that he finds a voice and a way to express himself. A lifetime of experience has gained him an exceptional level of skill and expertise in ceramic production and a tremendous knowledge of glazing and texturing techniques. He uses hand building methods, sometimes beginning with extrusion or throwing, to produce his organic forms and vessels, the surfaces are built up with repeated layers of slip and glaze added between firings.

Jim's artistic work is organic and highly textured, often retaining the imprint of the kneading and the folding, his thumb prints are his signature. Since moving away from the making of functional items, his work has taken on a more sculptural aspect (an influence from his architectural studies). He appears to be designing and building with clay and demonstrates an understanding of

the forces, limitations, tensions and beauty of his material. Some of his pieces could be scale models of much larger constructs, they could be ornate chimneys or giant towers.

Etain Hickey and Jim Turner are fundamental to the West Cork scene. They have been enthusiastic participants in all manner of art and craft activities, including networks, workshops, discussions and exhibitions. The old farmhouse in Rossmore has been home to their family and their business for more than 25 years. Over time the pottery workshop has been gradually extended and improved and their creative output has evolved and developed with it. Their passion for working with clay has influenced and inspired many other people in the region because of their continued generosity in sharing their skills and expertise. Being part of an exciting new craft movement during the 1980s has embedded the ethos of co-operation and collaboration in their souls.

next page, top left: *Black & White tall bottle forms, volcanic dry glazes*
top right: *2 Blue/white Pods, dry volcanic glazed*
right: *Winged Slipper!, dry glazed with lustres, rims and wings*

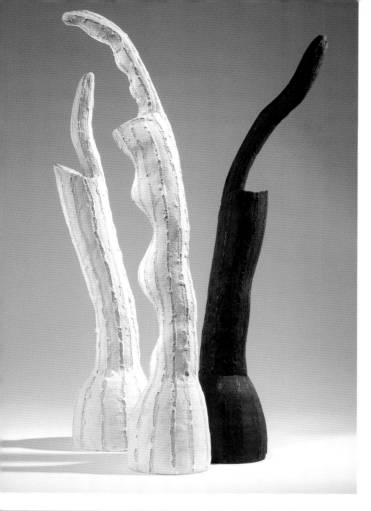

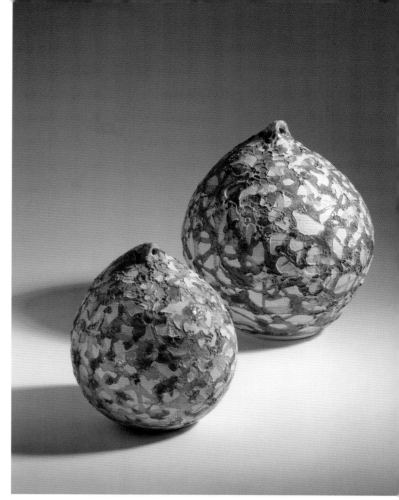

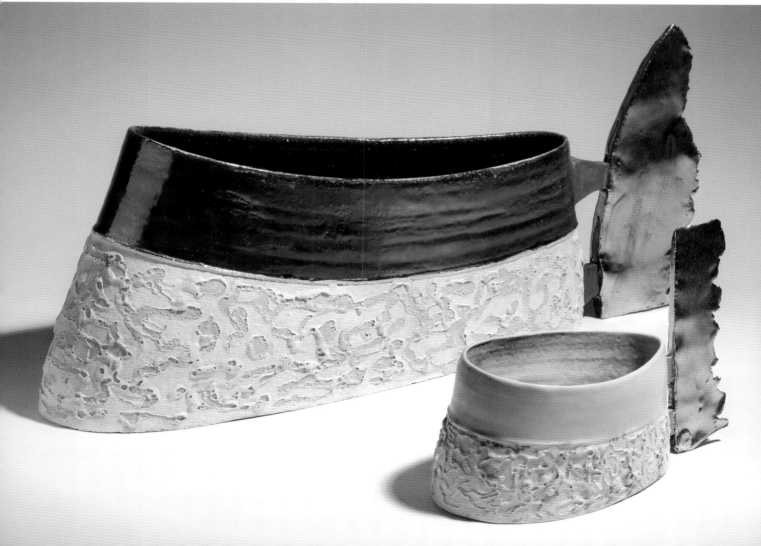

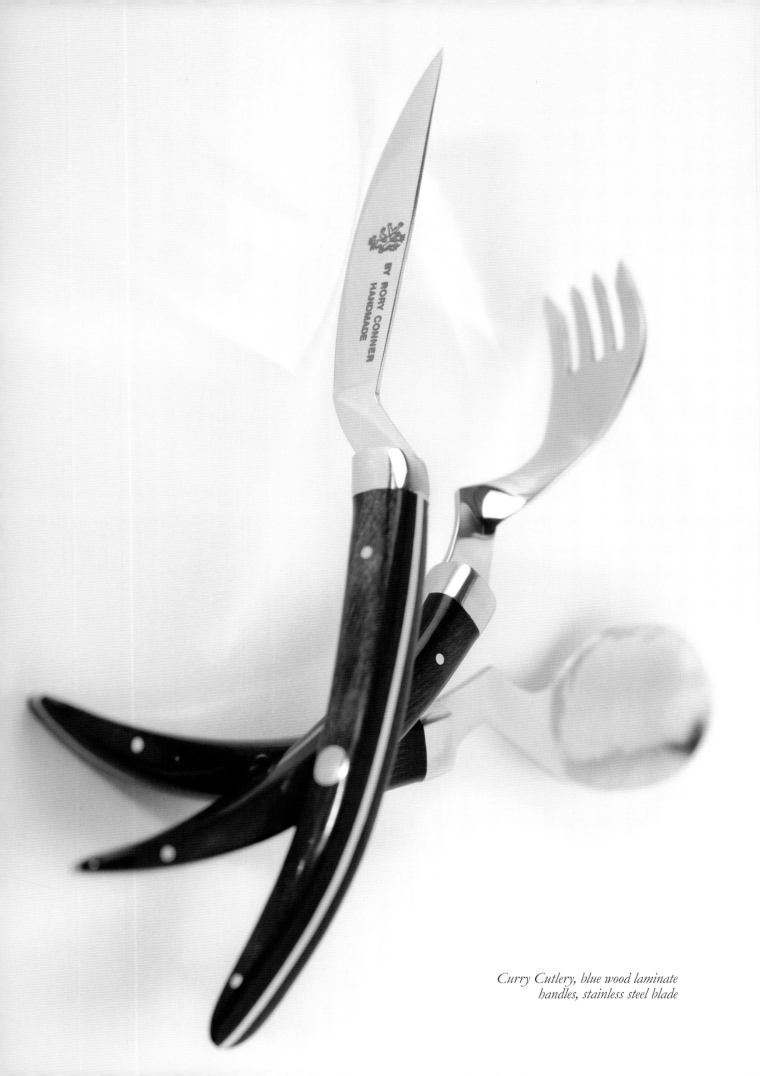

*Curry Cutlery, blue wood laminate
handles, stainless steel blade*

Rory Conner
Cutler

One of my knives in its sheath is about
the neatest package in all of design.
Bob Loveless (1929-2010)

A hand-crafted knife made by Rory Conner is a work of art, it is a beautiful object and feels almost too good to use. Some of his knives are designed as tools for hunting and fishing, others are household implements. The polish of the blade appears as liquid light and the sharpness of the edge is perfection.

Unlike many of the craftspeople in the region, Rory was born and bred in West Cork. His father was a Church of Ireland rector who had a welcoming attitude towards the influx of young people arriving in West Cork. He would offer practical help and advice to the newcomers and occasionally a good meal. Rory recalls being aware of this phenomenon as he was growing up. 'I remember a whole group of young people turning up at our house one day in a beaten up old ambulance, they were so different from the usual people around.

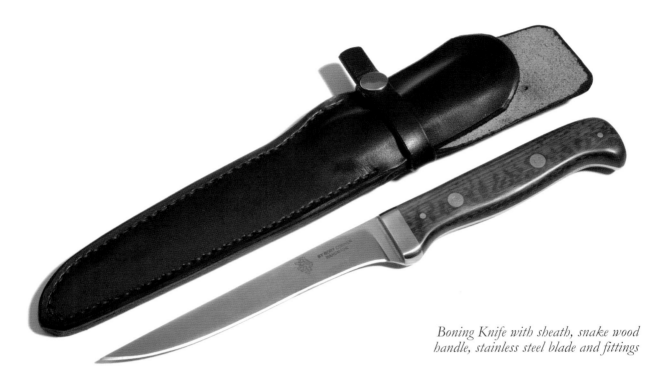

Boning Knife with sheath, snake wood handle, stainless steel blade and fittings

I thought they might be roadies for Led Zeppelin or something.'

When Rory first started to learn his craft, sourcing good quality steel for knife-making presented serious difficulties. As a result his early knives were made of steel reclaimed from car springs or from cheap imported knives which he redesigned and reshaped. He recalls that in the early days he was driven by a boyish urge to 'make shiny weapons' and set about this with the vision and determination to learn the necessary skills. With access to only a few basic hand tools, his first knives were quite crude but they possess a certain primitive charm and honesty. They are not slick or highly polished but their subtle simplicity is irresistible and they feel good in the hand.

Rory was encouraged to continue with his knife-making efforts when Christine Nicholas's *The Craft Shop* agreed to sell his

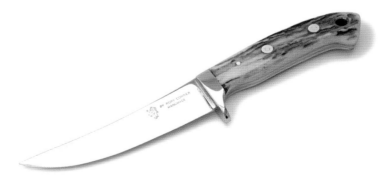

Freya Hunting knife, sambar staghorn handle, stainless steel fittings

work. For Rory, selling his early work was an important validation and recognition of his skill and essential to his survival as a craftsman. At this stage he was also making leather sheaths to hold the knives which made them very attractive and practical.

After winning awards for his knives in the annual Royal Dublin Society crafts competition in the early 80s, Rory set out to learn new techniques. He bought and borrowed books about knife making but realised he would need to leave the country in order to learn new techniques. He took a chance and wrote to world famous American knife maker Robert Loveless, requesting a period of apprenticeship. Loveless offered Rory a four-month training position at his workshop in California. At the Loveless studio he was taught the importance of using high quality materials and he learnt to design with both form and function in mind. Loveless himself had studied at the Institute of

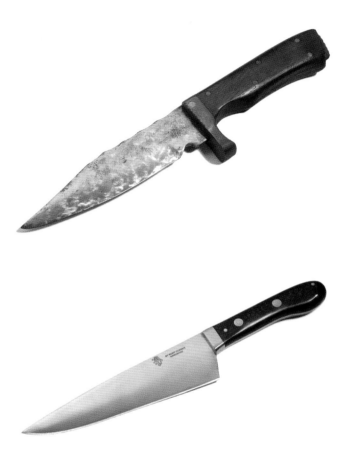

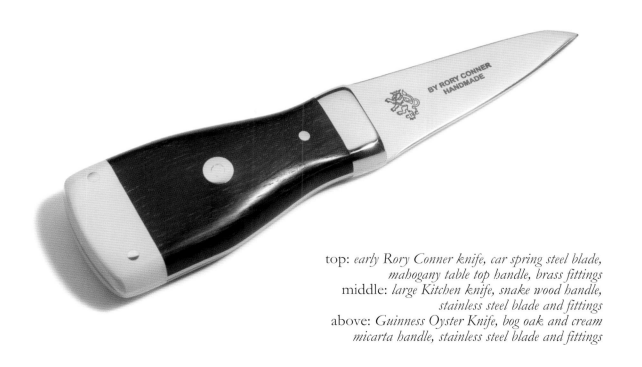

top: *early Rory Conner knife, car spring steel blade, mahogany table top handle, brass fittings*
middle: *large Kitchen knife, snake wood handle, stainless steel blade and fittings*
above: *Guinness Oyster Knife, bog oak and cream micarta handle, stainless steel blade and fittings*

Design in Chicago in the early 1950s and the Bauhaus doctrine of form follows function was the drive behind his pared-back, lightweight designs.

Until relatively recently it was commonplace for a man to carry a knife and women too kept a small decorative penknife in their bags. Knives were considered useful tools for a wide variety of tasks. Our distant ancestors would have used rudimentary blades made of stone, bronze or iron to kill their prey, to skin and divide up their meat and even to defend their territory, a knife was the essential tool for survival. These days most people are not used to working with edged tools and handling a new, very sharp knife feels slightly dangerous. We know that a knife can be a useful tool or a deadly weapon and we treat it with respect.

A well-made knife combines the skill of the craftsman with high quality materials, that standard applies to both the steel blade and the handle. The knife making technique that Rory uses is known as stock reduction in which the knife begins as a bar of $\frac{3}{16}$ inch thick stainless steel and is ground away and shaped by motor driven grinding belts of successively finer grits. This is meticulous, painstaking work which takes patience and skill. A good knowledge of metallurgy and engineering are essential as changes occur in the steel on a microscopic level. These changes can impact on the strength and durability of the blade, for example polishing not only shines the blade but also results in a stronger, better cutting edge.

Rory designs and makes handles for his bespoke blades, using a variety of materials. Knife handles are traditionally made from hardwoods although antler, horn and bone are also commonly seen. Handles need to be warm and comfortable to hold, as well as durable and attractive. Over the years, Rory has worked with clients to design and make knife handles that incorporate decorative gold, silver and ivory but most often uses highly polished and figured hardwoods with brass fittings. The knives are made by hand to his own design and exacting standard. He is a perfectionist with a love for design and innovation, constantly on the lookout for new ideas. His knives successfully combine craftsmanship, functionality and subtle beauty and are a pleasure to use.

previous page, above: *Cheese knife, steel blade with rosewood handle and brass fittings*
left: *Large kitchen knife, Damascus steel blade, laminate handle*

Marika O'Sullivan
Silversmith, jeweller, enamel artist

I want people to care about my work, not just want to acquire it.
Marika O'Sullivan

Marika O'Sullivan was travelling to the ferry port at Carrigaline in the summer of 1990 and parked her van beside the road to spend the night at the Four Crosses in Drinagh, West Cork. During the night she had a strange experience in which her vehicle was shunted several feet across the road, although there was no apparent cause for it. Marika mentioned her experience to a local woman the next day and was met with no surprise – she had parked in a place that was locally notorious and had been 'caught by the faeries'.

Like so many others, Marika felt the lure of West Cork. 'It has everything, a creative pulse and beautiful landscapes. I love it because despite being remote it is very cosmopolitan and because there is a large community of creative people here.' Unlike the early 60s, life had become more prosperous in the region with households

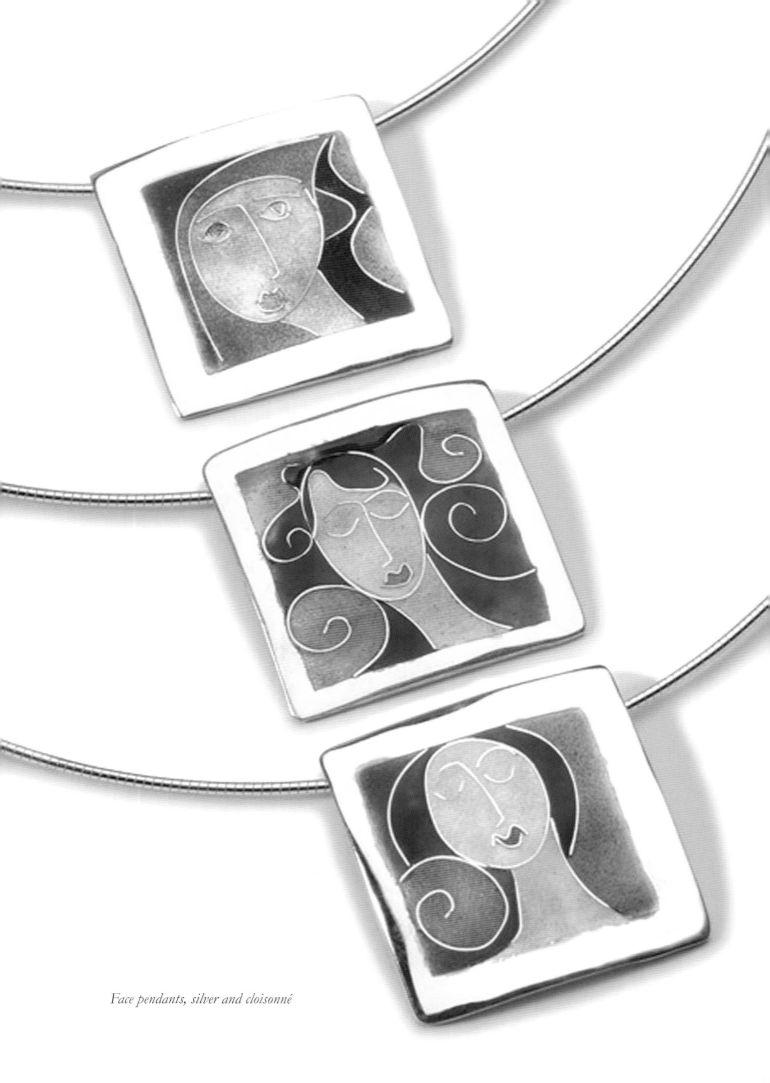

Face pendants, silver and cloisonné

benefiting from electricity, running water and telephones. Even so Marika recalls, 'when we first came to West Cork we were pretty poor and could not afford much of anything but somehow life was great, there was live music in the pubs and we would always meet other artists there'.

Marika had been presented with an enamelling kit for her twelfth birthday. She was naturally creative and her parents encouraged her with crafty gifts for all occasions. The kit contained a miniature kiln and Marika became absorbed in the craft, spending many hours alone practising and learning how to work with the materials and tools. Later in life she came back to enamelling and built on the skills she had taught herself at an early age. Working from books on jewellery making, she began to learn the mysteries of silversmithing and cloisonné. This technique has its roots as far back as the 5th century BC and involves creating designs from thin metal wire on a base and filling the separate fields with different coloured enamel powder. It is an unusual technique that allows the artist to create intricate and stunningly beautiful work.

Soon after arriving in West Cork, Marika met Gert Besner and Sabine Lenz. She often accompanied Sabine on the long journeys to Kilkenny where they both attended Crafts Council of Ireland jewellery making courses. Sharing ideas and resources with other craftspeople was an important aspect of life in West Cork and as Gert was a trained and experienced goldsmith, his advice was always welcome. From 1994, Crafts Council tutor Jane Huston organised an annual programme of short courses in specialised jewellery-making techniques,

Silver bracelet, necklace and earrings with enamel

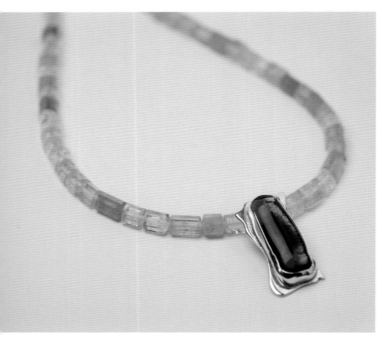

above: *Silver and enamel salt pot*
left: *Fused glass set in silver with aquamarine beads*

such as gem stone setting, casting, enamelling and design. The courses were aimed at teaching the necessary skills to those wanting to set up their own businesses or be employed in the trade.

Marika works in a very traditional way and does not use anything remotely technological in her creative process. Although the kiln is a modern innovation enamelling has been done with limited technology since pre-historic times. A pestle and mortar are the traditional tools for grinding glass, finer glass powder gives clearer, more vibrant colours. In Ireland, enamel was used to embellish metal weapons and decorative Celtic jewellery. As it is fired at high temperatures, enamel is very hardy, it lasts for many hundreds of years without the colours fading.

The addition of colour to her silver pieces is an essential part of the creative process. 'Other jewellers finish their work by burnishing and polishing, I add enamel because without colour my pieces would feel incomplete.' Marika's designs often come from how she feels. The faces depicted on brooches and pendants capture fleeting emotions with a few deftly placed lines. Faces are a recurring motif in her work, as human heads were in Celtic weapons and jewellery. Marika's faces have a sense of the familiar or talisman about them, as if their potent energy might give the wearer protective or life enhancing powers.

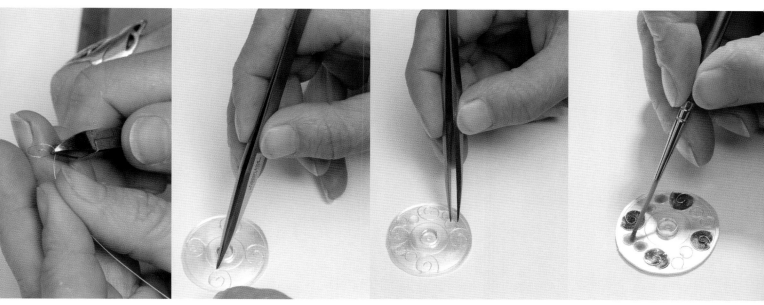

Marika preparing background for cloisonne enamel

Spectacular views and beautiful surroundings play their parts in the creation of Marika's exquisite work. Her studio has large windows with views in all directions, looking out on a green landscape touched by light which abruptly changes because of the wind, the clouds and the sea. Her palette is also inspired by the aquatic blues, greens and turquoise of the Atlantic Ocean as seen from the strands of West Cork.

Unlike many craftspeople, Marika enjoys selling her work. She feels it is an important part of the process. 'When I make a piece of jewellery, I feel that I have made it for someone and it's a great satisfaction when that person finds the piece and loves it.'

Working with glass is a kind of alchemy and working on such a minute scale requires dexterity, creativity and vision. It is physically demanding to hand and to eye and yet Marika's work is pervaded by an intense and evocative love of colour and form.

Road between Skibbereen and Ballydehob

Landscape with Gold Sea vase
15cm diameter, hand thrown, slips, glazes, gold and pink lustres, 2005

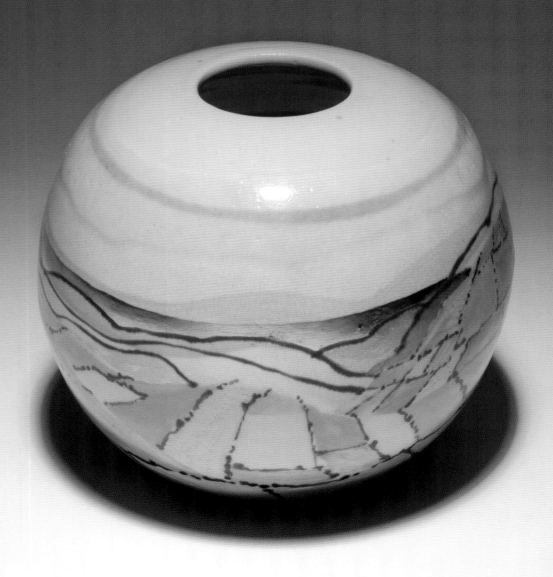

David Seeger
Artist

I love the challenge of working with colour, the design just seems to grow of its own accord.
David Seeger

David Seeger is an artist who dislikes being labelled either as a painter, a sculptor or a ceramicist. He is highly accomplished in all three disciplines and sees no boundaries between them. Many of his ceramic forms are sculptures which he has painted with glazes and coloured slips. David could also be described as a seeker, exploring unconscious sources of inspiration through studying the psychological ideas of Freud and Jung.

David's father was a textile designer and expert colourist. His uncle, and grandmother were enthusiastic practising and exhibiting members of Bradford Arts Club. One of the UK's few remaining old fashioned country ceramic producers, *Soil Hill Pottery*, was relatively local to his home. In the late Thirties and early Forties, Davids grandmother became a very good customer of its owner Isaac Button. For her contribution to the fund-raising for the new building for the grammar school, she purchased large quantities of small dry but unfired slipware items. She decorated them, *sgraffito* through the slip revealing the red

clay, then returning them for glaze firing to the pottery. These pieces are among the first memories David has of being inspired by the beauty of handmade pottery.

David attended school in Bradford and went on to study Fine Art and Sculpture at Leeds College of Art. The College was involved during that period, in a pioneering experiment in art education under the leadership of Harry Thubron, who became Head of Fine Art in 1956. Thubron was inspired by the German Bauhaus College and the writings of Herbert Read to establish a system of education which prioritised the development of visual literacy in the use of colour and form. Read's *Education Through Art* puts forward the thesis that 'in the 20th century the subjective needs of man and objective reality in the form of modern society, have drawn apart to such an extent that man's whole future is endangered'. He proposed that education through art is the means by which this dangerous rift can be rectified. David was fortunate to be selected for the famous summer schools programme where Thubron's philosophies and ideas about art education were shared with teachers, artists and students alike.

During the revolutionary 1960s, the creative climate was energetic and progressive. Students were rioting in Paris and protesting against the Vietnam War in the United States and London. In Europe, young people began to shift away from traditional, conservative moral traditions and towards a more liberal, idealistic way of seeing the world, with a specific focus on education and employment. Students like David were in the vanguard of the movement for change. In his final year, David was invited to teach and did so while continuing to make and exhibit his own work. During this time he produced a range of slip cast objects, decorated with silver lustre, he experimented with ideas of space, form and light. The

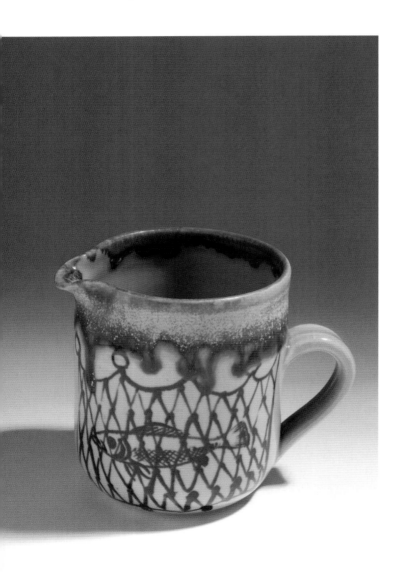

'Fish' jug
Who is in the net? You or the fish?
10cm high, stoneware, handthrown, glazes and cobalt oxide brushwork, 1999

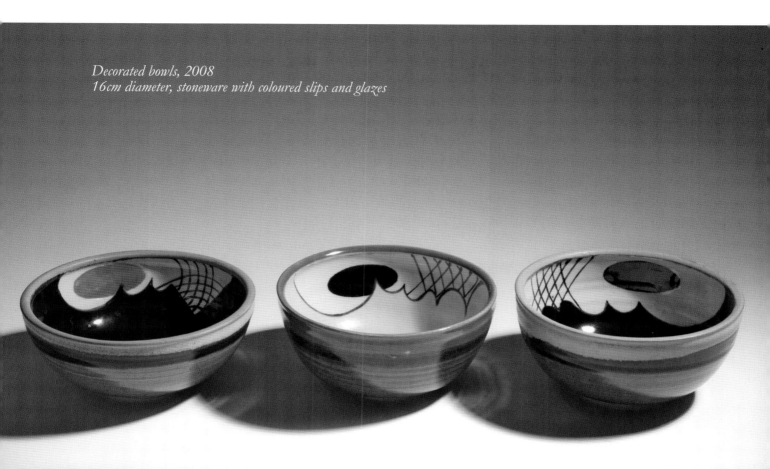

Decorated bowls, 2008
16cm diameter, stoneware with coloured slips and glazes

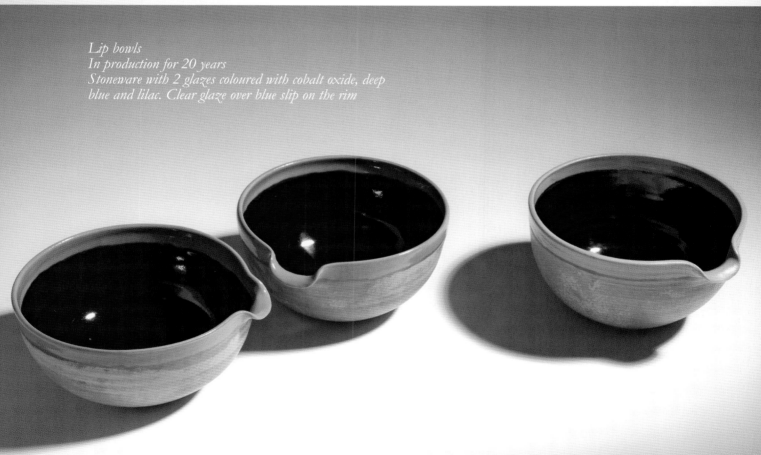

Lip bowls
In production for 20 years
Stoneware with 2 glazes coloured with cobalt oxide, deep
blue and lilac. Clear glaze over blue slip on the rim

pieces were sculptural and surreal, recognisable objects with a tenuous hold on functionality.

He applied his innovative approach as much to his teaching as to his own work, passing on the valuable knowledge and wisdom that he had received as a student, 'everything was experimental, you didn't have to be a painter or a sculptor, you can make a sculpture and paint on it – there were no boundaries'. In line with his own learning experience he assumed the role of facilitator, raising the self esteem of learners, teaching by example. David also taught at the Barry Summer School in Wales where he encouraged participants to experiment with kites, balloons and smoke to create ephemeral aerial sculptures.

For eighteen years David taught and lectured in Art colleges and schools in the UK before deciding to leave education and concentrate on expanding his own artistic practice. He had often thought of moving to a more peaceful and inspiring location and decided to look at the possibility of living in Ireland. David and his partner Ruth spent some time touring the west coast, looking at houses and getting a feel for the country. When they arrived in West Cork they felt that everything seemed right – the people were friendly, the landscape had a wild and rugged beauty and most importantly, it had an atmosphere of peace and tranquillity.

Since moving to the region 1990, David has developed an intense interest in the natural world and an emotional connection to West Cork. The colours of the landscape, the sea and the sky are all visible in his work, he continues to experiment and play with colour and a new palette has emerged. His hand-thrown white stoneware pieces are decorated with a variety of unique glazes devised and concocted in his own studio and often re-fired with precious metal lustres. Many of his ceramic forms could be described as three dimensional paintings and an enthusiastic response to the landscape but it is his use of colour, ultimately that attracts and captures the attention. In 1989 David completed a Masters Degree on Marc Chagall's paintings. According to Chagall, 'when colour is right, form is right. Colour is everything, colour is vibration like music; everything is vibration'.

David has discovered an affinity with nature and carefully observes the wildlife and seasonal changes revealed in the landscape around him. He also grapples with the 'mystery of the moon' planting his vegetable garden according to the lunar cycle. His interest in the patterns of nature has led him to explore geometry and illusion, creating trompe d'oeil designs and playful images which appear on his sculptural and functional ware. Although his roots are unequivocally in Bradford and his background in the modern art movement, David's work has been hugely influenced by living in West Cork where he has succeeded in blending both strands of his existence into one impressive body of work.

previous page: *Möbius teapot*
24cm high, slipcast white earthenware, clear glaze with bright platinum lustre and black enamel. One of a series of one-off variations from the same mold, 1979

Sabine Lenz
Jewellery designer

I believe that jewellery has always been and still is a magical companion.
Sabine Lenz

Sabine Lenz is an exceptionally creative jewellery designer who aims to produce pieces that carry a message and create an emotional connection between the jewellery and its wearer. Her work artfully combines modern design with inspiration from Irish mythology and Celtic script found in the lavishly illuminated *Book of Kells* and *Book of Durrow*. Her highly contemporary pieces resonate deeply with the past and Sabine's passion for working with metal links her to the jewellers and goldsmiths of ancient times.

Perhaps Sabine was drawn by subconscious ancestral connections to the very area where copper was mined and traded during the Bronze Age on Mount Gabriel, West Cork. Her ancestors could have been amongst those responsible for introducing Celtic decorative metalwork into Ireland over two thousand years ago. La Tène

previous page: *Water and Waves necklace, 1999*
oxidized sterling silver, 18ct gold, green sapphires, green tourmaline

'My Dream' necklace, silver with pearls and gold detail

culture is known to have developed around 1500–1000 BC in Gaul (an area that included parts of Germany) and has long been associated with advanced forms of metalwork, decorative ornamentation, jewellery and goldsmithery. The La Tène civilisation established trading connections with Ireland before the 4th century BC when Iron Age trade routes were opened along the Rhine and Danube waterways. This culture was virtually eradicated by the Romans and then continued to exist in the few places which had not been influenced by Roman occupation, such as Ireland.

In 1991 Sabine was studying fashion at the University of Hamburg when she decided to spend the summer back-packing in Ireland. On arrival, she was immediately enthralled by the wildness of the Irish countryside and felt she had arrived in a very special place. 'I love the wilderness here. In Germany there are beautiful places but there are always people, everywhere you go, always noise, people and cars. I couldn't believe how beautiful and remote it felt to be here, I just wanted to stay.'

Hitch hiking out of Westport she was picked up by a driver who she had noticed in the town earlier and had decided from his dark good looks that he was probably an Italian tourist. Somewhere along the way they stopped at a pub and the mysterious man introduced himself as Len Lipitch from London and according to them both they fell in love. Sabine came back to West Cork with Len and very quickly made the decision

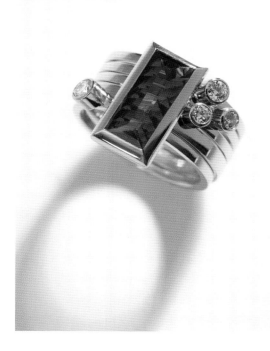

to drop out of her course in Hamburg and move to Schull. 'It was the most difficult decision I have ever made but I knew I would regret it if I didn't take the chance.'

At the time, Sabine had no formal training in making jewellery. She had always been fascinated by the idea of making three dimensional objects and had experimented with simple designs using brass, beads and mirrors. Sabine and Len moved into a small caravan without electricity or running water where they set up a tiny workshop and Sabine gradually taught herself the skills and techniques required for making jewellery. She was confident that she had a good eye and had a natural flair for knowing what people would buy. Sabine recalls, 'during that time there was very little competition in West Cork and I was excited to find that even at the beginning, my work was selling really well.'

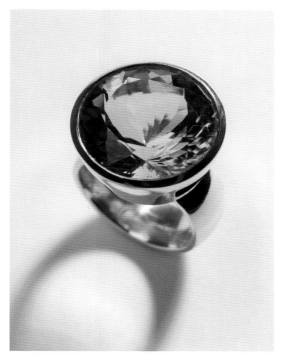

Len and Sabine called their new business *Enibas* and Len wrote a business plan which convinced the West Cork Enterprise Board to support their plans from the outset. The WCEB helped them with grant funding, first of all to equip their own workshop and subsequently by providing them with a purpose-built commercial unit which gave them workspace for production and training employees. Sabine remembers, 'It was very tough and there were times when I could have given up, we made so little money but Len always supported and encouraged me, he was the one with the business mind'.

top: *5 x Stack Ring, 18ct gold, platinum, tourmaline, diamonds, 2009*
middle: *XL Ring, sterling silver, citrine, 2009*
right: *Water Ring, 18ct gold, aquamarine, 2008*

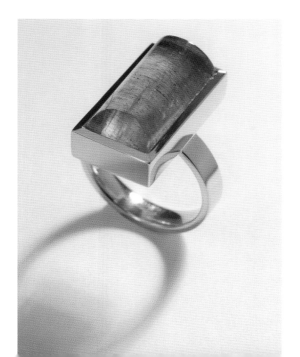

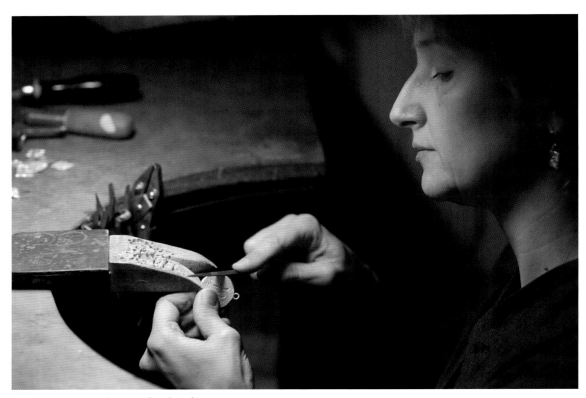

Sabine Lenz working at her bench

In order to develop her jewellery-making skills, Sabine made long journeys to attend regular week-end courses run by the Crafts Council of Ireland in Kilkenny. Jane Houston was the main tutor and Sabine describes her as 'the most influential mentor I could have found, she was helpful to me on all fronts. I could phone and ask her anything at all about retail, making, materials and so on. I owe so much to her…I recognise now how hard it is to learn by yourself. It can take you two years to discover something you could learn in five minutes on a course'. Other craftspeople and jewellers in West Cork, such as Gert Besner were very generous with their time and offered Sabine the use of their workshops and helped her to extend her metalwork skills.

Looking back over twenty years, Sabine recognises that she arrived in West Cork when conditions were especially propitious for starting out as a jewellery maker. 'I came from a country where every town had an upmarket goldsmith, none of that existed here. I feel very lucky to have come here at a time when craft was just beginning to be recognised. It was a great opportunity for someone like me, who didn't have the technical background, to thrive.'

In 2001 the *Enibas* shop opened its doors in Schull, selling Sabine's own handmade jewellery and other carefully selected crafts. Sabine is always looking out for new products which are not just simply well made but are exciting. She believes that people come into her shop looking for

something special – something to stir the soul. Her two poles of existence, a large metropolitan centre in Germany and the remote wilds of West Cork could not be more diverse and yet she successfully combines the intellectual with the spiritual. Her innate desire for precision and perfection, blends uniquely with the emotional depth and creativity inspired by West Cork

right: *Masks, wood found on the beach, sterling silver, 1994*
below: *Celtic Script Symphony necklace, sterling silver, rutilated quartz, 2008*

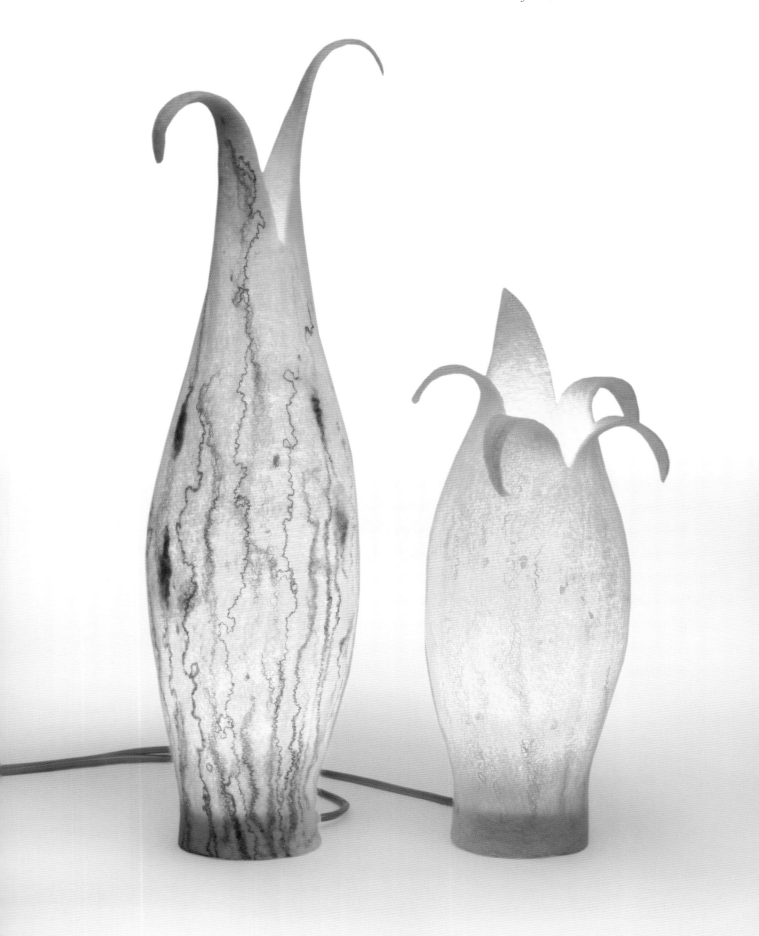

Pod Lights
handfelted from merino wool,
silk fibres, silk and linen threads

Helen Stringer
Textile artist, feltmaker

Felt is all about the feel.
Helen Stringer

Helen Stringer moved to West Cork in 1996. She had been living in south-west England and was attracted to West Cork for its unspoilt pastoral landscapes and relatively cheap housing. She was aware of the large community of artists and creative people living in West Cork, 'it seemed like a friendly place where I would have the freedom to follow a creative lifestyle'. Before leaving the UK, she had participated in a community arts project aimed at teaching young people how to make felt, with the objective of constructing a full-sized yurt. During this experience she discovered a real taste for felt making, in fact she 'loved it from the start'.

Anyone who has spent time in West Cork knows that seemingly random events can result in important life changes. Shortly after moving to the region, Helen found herself unexpectedly in possession of two large bags, stuffed full of brightly coloured fleeces, donated by a friend who was moving away. She grabbed the opportunity to practise the techniques she had learnt and before long had used the fleece to make four cushion covers, which she sold at the

Christmas Craft Fair in the West Cork Arts Centre, Skibbereen. Since then, Helen focussed her attention on learning the ancient skills of felt making, whilst exploring her passion for colour, texture and surface design. She has experimented with using a variety of materials and continues to discover what felt is capable of especially in terms of creating three dimensional shapes.

Helen Stringer preparing the design for a merino fleece felt wall-hanging

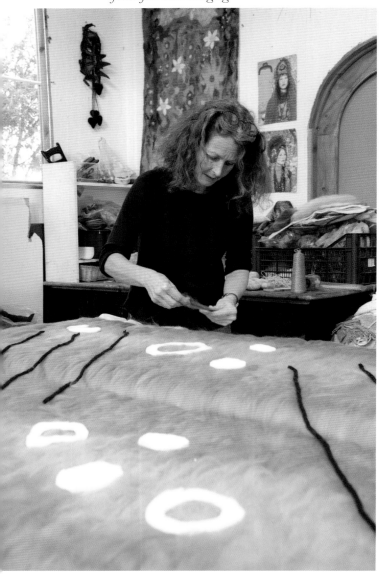

Felt making is physically demanding and requires both strength and stamina. During the process, light, fluffy fleeces are turned by friction into a material that can be anything from soft, lightweight and flexible to dense and impenetrable while the fibre remains strong and malleable. It is a slow, contemplative process allowing the artist's hands to explore the material and intuitively create by touch. The hand becomes the tool, manipulating and shaping the form, judgements are made by touch and instinct. The felting process requires large amounts of hot water and soap. The artist cannot avoid submerging their hands for long periods, with some felting taking up to ten or more hours, depending on the size of the piece and the necessity for strength and density. Helen is constantly experimenting with fibres and often includes silk threads, curly fleece from Wensleydale sheep and occasionally soya bean fibres. She works with pure merino fleece to create a smooth, even surface for her wall hangings, often layering it on top of hard-wearing mountain fleeces which are ideal for making dense, solid backgrounds.

During the 1990s, interest in felt making experienced something of a resurgence, although it was still considered by some to be a hippy or ethnic craft or mostly found in shops specialising in products from Nepal and Tibet. Helen's vision at that time was to make something more attractive to the contemporary craft market of the early 2000s. She decided to develop a product that was modern and innovative which she

next page, top: *Lanterns, 'arashi shibori on prefelted cylinders, 15cm diameter*
right: *Selection of Vessels, handfelted from a variety of natural coloured fleece*

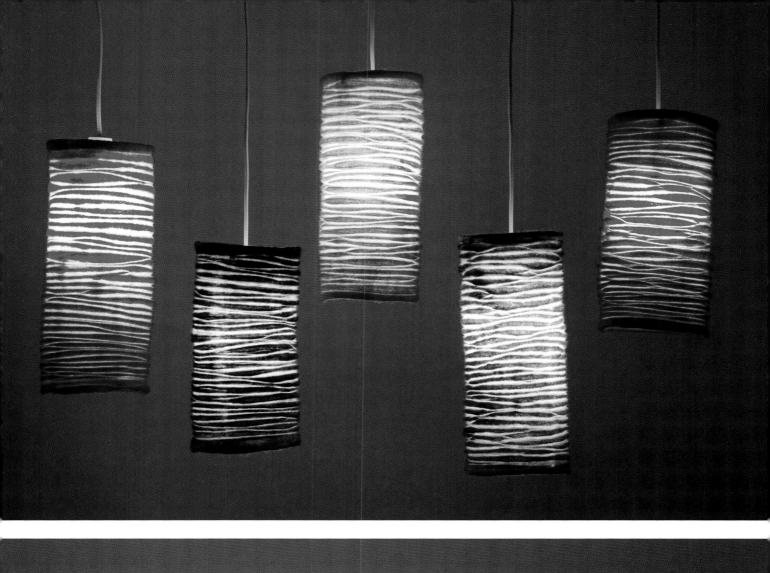

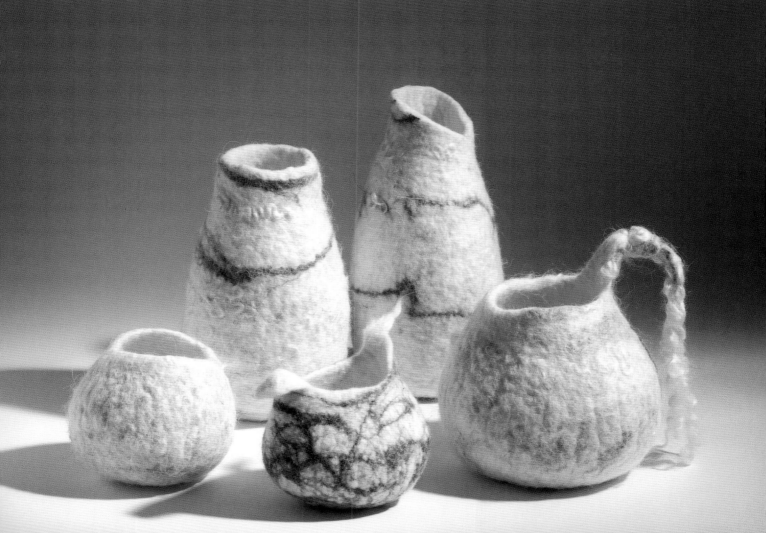

could make in her own small studio, in reasonably large quantities for sale to mainstream shops.

The new product that came out of this process is the pod lamp. In making these pods Helen explored felt's sculptural properties and its translucence. Traditionally it is a material that is dense, protective even, keeping out the elements and light. In making lamp shades out of felt, Helen challenged these preconceptions, presenting ways of showing the layers of texture and fibre beneath the surface, by illuminating the fabric from behind. It is a material that allows unparalleled freedom of form and colour and Helen exploits its sculptural qualities in her lamps and exquisite baby slippers and vessels. She makes the most of the wonderful array of pre-dyed fleeces that are available today but is moving back towards more natural colours, using fleeces from sheep raised in Ireland.

Helen's felt-making journey has brought her back full circle to the materials she first learnt to work with. After many years of making pod lamps and brightly coloured wall hangings, she is satisfied that she achieved her goal, she helped to rescue felt from its hippy pigeon hole but she is now looking to push her designs in other directions. 'I want to go back to working with Irish fleeces, there is something satisfying and real about a Kerry fleece. It might seem lumpy and tough compared to merino wool but it has a kind of integrity, it is primitive and functional and like the sheep it comes from, entirely suited to the Irish climate.'

It is clear to see her influences when visiting

her workshop during the summer months, in the riot of colours in the flower bed in front of her workshop. The colours of each season clearly impact on her work, with pieces inspired by brilliant green bracken, golden buttercups, and bright pink fuchsia in summer and mellow granite shades and sombre tones for autumn and winter. Even the pod shape forms are reminiscent of fuchsia buds and rose hips.

Helen's new work combines fifteen years of creative experience with her wish to use more natural, indigenous materials. Her vessels appear to contradict the medium, to the eye they could have been thrown on a potter's wheel or even turned on a lathe but in reality they are light and flexible to the touch. The earthy colours and natural forms reflect the palette and smooth undulations of the West Cork landscape, while the making skills are strong and understated.

previous page, top: *Crinkle Scarf, mokume shibori on nuno felt, 20x50cm*
far left: *Seaweed Scarf, mokume shibori on prefelted merino wool*
left: *Felted merino wool fairy lights*
right: *River Run, handfelted Irish and merino wool, 60x200cm*

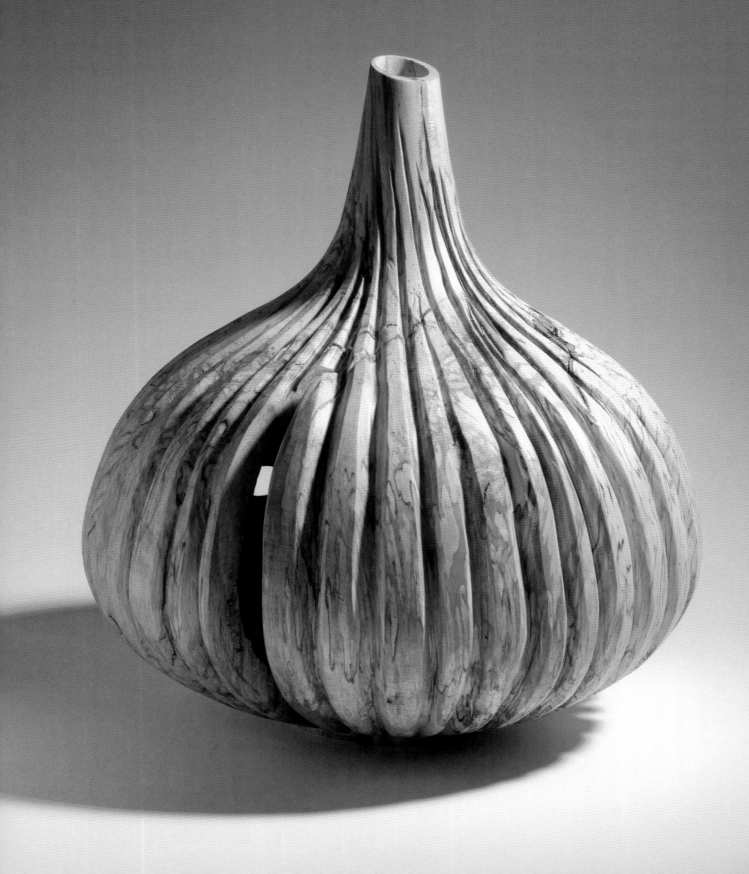

Hollow bottle form with exterior carvings
spalted elm, 35×39cm

Kieran Higgins
Wood turner

Some woods whisper, some talk, others shout, but bog oak screams at me, it will not be ignored.
Kieran Higgins

Kieran Higgins came to both West Cork and to wood turning through unexpected paths. Originally from Kildare, he used to visit West Cork on a regular basis to indulge his other passion of sea angling. He gradually realised that regular visits were not enough and visited more and more often and did not want to leave. A local friend told him 'to some people West Cork is like an invisible hand, it reaches out and keeps pulling you back'.

Kieran always had an interest in making things from wood, as a child he made ships and toys for himself and in later years he attended evening classes in woodwork. He left school at a time when employment was hard to find and was pleased to secure himself a job with the national telephone company (now called Eircom). Earning a salary however was a means to an end; he began buying and collecting tools and equipment, attending woodwork shows and

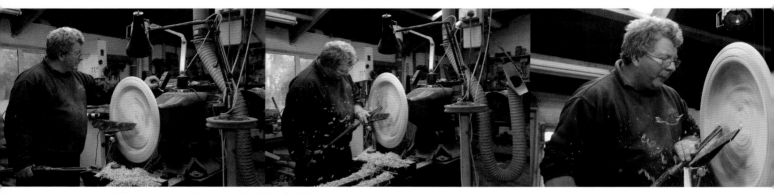

Working on a large spalted beech dish

developing his skills. He finds inspiration in the wood itself. 'I can't explain what it is about wood that I love, I just find it a very warm, yielding material and a joy to work with.'

Having watched an impressive demonstration of lathe work at the Dublin Brighter Homes exhibition in the early 80s, Kieran began to think about wood turning. A friend gave him two turning chisels, he purchased a lathe, joined the local chapter of the Irish Wood Turner's Guild and began to practise. Evenings, week ends and holidays were spent at the lathe, every spare minute was dedicated to learning new skills, experimenting with an ever increasing number of tools and developing a new understanding of working with wood.

He started, as most turners do with making lamps and salad bowls, learning by practice and from watching fellow wood turners demonstrate their skills and techniques. He loved the functionality of the pieces he was making and how turning revealed the grain pattern and underlying beauty of the wood. Turners tend to judge their own work and that of others by how thin the walls are. Many attempt to turn vessels so thin that

the walls are translucent. This demonstrates impressive skill, working gradually at the timber and stopping just before the chisel breaks through, making a vessel that is light and fine.

Kieran's material of choice is bog oak and it is not a wood that can be turned thin, light or fine. Bog oak is a very hard material and in many ways behaves differently from all other timbers. It is formed when trees get buried in peat bogs and preserved from decay by the acidic conditions. Oak trees can be preserved in this way for hundreds or even thousands of years. From time to time they are uncovered and rise spirit-like to the surface as a reminder that Ireland was once covered in dense primeval oak forest. Bog oak has very striking colouration, fading from black on the outer annual rings to dark brown at the heart, it polishes to a rich deep lustre.

The creative process is the most mysterious aspect to any craft. Being open and receptive allows us to develop new ideas and respond naturally to our materials. In producing his natural-edged, large scale bowls and vessels Kieran observes and listens to the wood, adapting the design of

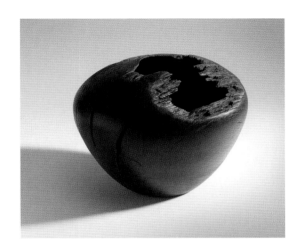
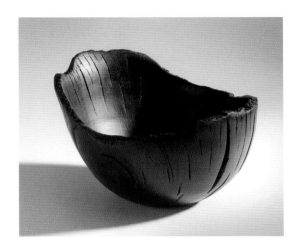
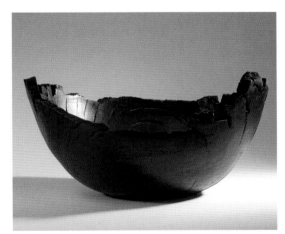

top left: *Hollow form, bog oak, 32x27cm*
top right: *Bog oak with natural edge, 22x15cm*
middle left: *Bog oak bowl with natural edge, 27x48cm*

middle right: *Bog oak bowl with natural edge, 35x48cm*
above left: *Burr (Burl) elm closed form, 25x30cm*
above right: *Bog closed follow form, 12x45cm*

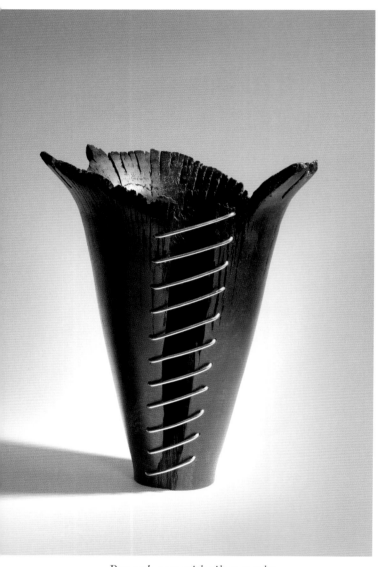

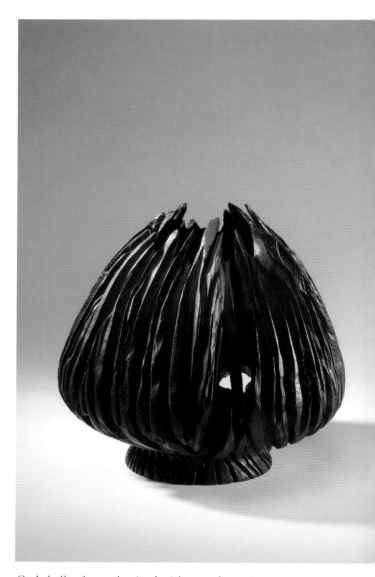

Bog oak vase with silver staples

Oak hollowform, ebonized with carved exterior

each piece as the work progresses, blending his creative impulse with his knowledge and skill. When selecting a piece of bog oak Kieran first acquaints himself with all the cracks and splits, predicting where possible how it will behave when spinning at 800 revs per minute on the lathe. He has developed a thorough understanding of the material and enjoys the sense of collaboration between timber, tool and

hand. As he turns, he feels the story of the tree is revealed through the texture and grain of the wood. 'You work *with* the wood, finding ways to incorporate the splits and the cracks.'

Kieran feels it is important to put his work up for sale. 'You must have confidence in your work if you want to try and sell it.' He believes it is important to hear comments

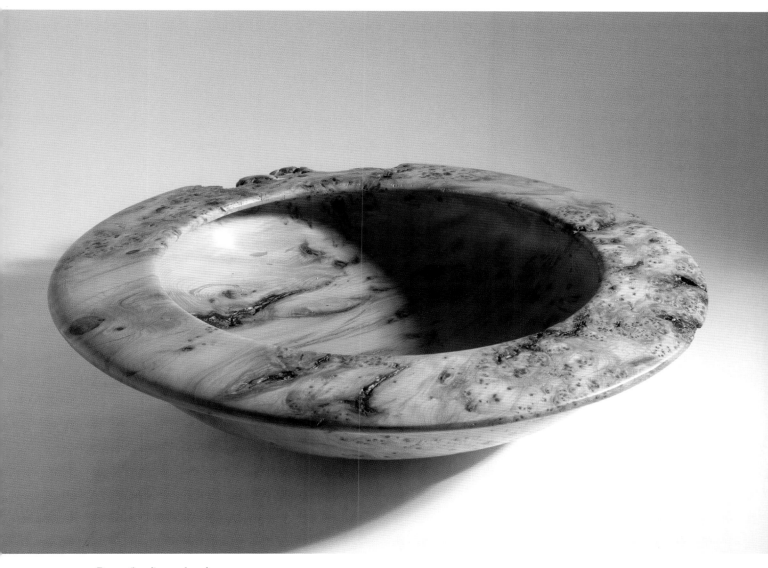

Burr (burl) yew bowl

and feedback from fellow wood turners and potential customers alike. Kieran particularly likes hearing 'you are a brave man to turn a piece of bog oak that size' and enjoys watching people's reaction to his large vessels and platters. He notes, 'you can tell that they want to touch, most people start by cupping the piece in their hands and lifting it to feel the weight...then some go on to hug it – people love wood'.

Turning large bog oak pieces has become something of a signature for Kieran, and has challenged him to develop new tools and techniques for shaping and finishing his work. The size and nature of the material is fraught with problems but the solutions he finds are wonderfully creative. Not bound by tradition, he is free to explore the possibilities of working with bog oak and like all craftsmen, finds himself through his materials.

Lough Allua

Conclusion

Ní neart go cur le chéile (no strength without unity). Irish proverb

Between 1961 and 2000, a West Cork aesthetic emerged that was inspired by the landscape and created by the artists who came here. From the earliest days, the movement has been nurtured by the local population who seemed to understand and appreciate it quite instinctively, despite being very different from anything seen here before. Because of that acceptance and recognition, the artistic community has thrived and prospered in West Cork and excellent, innovative craft has become an important part of the region's cultural heritage.

West Cork was a very different place when the first artists began to arrive 50 years ago. The 1950s had been a particularly difficult decade economically for Ireland and many young people had been obliged to look for better prospects abroad. As a result, population figures in areas like West Cork were severely diminished especially amongst people of working age. House prices were likewise depressed and there were plenty of derelict and semi derelict properties on the market. At that time, traditional crafts such as basketry, shoe making and weaving were disappearing, those products having been replaced by cheaper, mass produced goods which were generally imported. Although handmade crafts were becoming fashionable in the more prosperous and urbanised parts of Europe, the studio craft movement had not yet made an impact in Ireland. Therefore, young people, many

with degrees from Art colleges and most with very little money, saw West Cork as a place where they could live and follow their dream. It offered unspoiled landscapes, the opportunity to be self sufficient, very cheap housing and little or no competition from an indigenous contemporary craft market.

However, handmade craft has long been an important part of Ireland's national identity, although it is usually referred to in terms of historic artefacts, recognition of contemporary craft has been slow in coming. Although the West Cork creative community 'phenomenon' was picked up by newspapers and the media who recognised it was 'a good story,' it has not been taken on board by state agencies as something essentially Irish, perhaps because a significant number of the artists were not originally from Ireland.

Perhaps too there was an element of condescension towards craft in favour of art (something I encountered time and again while researching this book). This concept first came to light in *The Enlightenment* with the philosopher Immanuel Kant describing works of art as 'intrinsically final', without having have a useful function, appealing purely on the level of emotion and imagination. I feel certain that the 'art' criteria as formulated by Kant could easily be applied to most of the pieces photographed for this book and in the final analysis, all art and craft

techniques are expressive and of equal value, in so far as the art or craft is good. As craftspeople, we put something of ourselves into every piece that we produce and by infusing it with passion, our work transcends its utilitarian purpose. The creative process requires a state of mind in which we are open and receptive to inspiration. Once a craftsman has attained a certain high level of skill, his brain, hand and eye work together automatically, allowing the mind to design and create on a subconscious or intuitive level.

The fortunes of artists living in West Cork have risen and fallen as economic conditions have fluctuated. Certainly during the 1960s and 70s craft was viewed as modern and fashionable and customers were not too difficult to find. Local people and visitors alike were excited by the new products on offer and the alternative life style being led by those vibrant and colourful young artists arriving from all over Europe. During the recession of the 1980s many people struggled to make a living but most of the founder members of the Cork Craftsman's Guild are still living in West Cork, having survived the challenging times. Strangely, the so-called Celtic Tiger years did not necessarily result in increased orders for craft producers. The commercial feeding frenzy that typified the period was mostly limited to mainstream retail outlets and cheap, mass-produced, imported goods.

The presence of so many artists and craftsmen in the region has produced an atmosphere of creative excitement and experimentation especially as artists were happy to share their skills and resources. As the group expanded and new members were welcomed in, new ideas and techniques were brought into the mix, reflecting the variety of artistic backgrounds. The community shared an enthusiasm for innovation and originality but perhaps it was their shared vision which helped build a lasting reputation for artistic endeavour in the region. It could be argued that the key aspect of the craft movement in West Cork was not the quality of the work that was produced, but the sense of solidarity and the community that was created.

One could also argue that this craft movement was strongly influenced by three key disciplines: the Arts and Crafts movement which originated in the UK; Bauhaus design and Japanese philosophy. Many of the artists who moved to West Cork were highly aware of these schools of thought, some indeed had been taught by Bauhaus graduates. Like William Morris of the Arts and Crafts movement the Bauhaus School theorised that design should serve the needs of society, products should be simple, clean lined and affordable, 'form follows function'. Meanwhile, Bernard Leech and Soji Hamada had introduced a fusion of Japanese and British pottery with the ground breaking *Leach Pottery* in St Ives.

Leach and Hamada described the process of making pottery as the 'combination of art, philosophy and craft'. Central to Japanese aesthetic ideals are 'shibui' meaning simplicity and reserved beauty and 'wabi sabi' which celebrates transient and imperfect beauty. Both views depend on the stripping away of everything that is not

essential. In the early years, most of the pottery being produced in West Cork (and beyond) had its roots in this kind of product – organic forms with little ornamentation and earth-toned glazes.

These three movements or philosophies therefore shared many of the same goals and all retained a strong connection to nature and the organic form. In particular, they linked the pure arts with craft skills and rejected unnecessary divisions between the disciplines. They emphasised and celebrated the beauty of natural, 'honest' materials and argued that objects should be designed in a simple and unostentatious style and should be 'fit for purpose.' The central tenet of all three movements was that beautifully designed, well-made work brings us joy and enhances our lives.

Some of the finest makers in Ireland learnt and developed their craft skills in West Cork where they were influenced by diverse interactions and traditions. What remains outstanding in the work produced here is its originality and attention to detail. The time is ripe for recognising the value and potential of the craft sector in Ireland and putting in place the necessary structures to support the makers and promote the work. It has been done before in West Cork and as a result the region has established a tradition of excellence. With support, the sector could flourish again and bring new prosperity to the country as a whole.

Acknowledgements

Many people have helped me to write this book. Often we drank cups of tea while they reminisced about the 'golden era' of art and craft in West Cork. I appreciate their generosity and willingness to share their time and knowledge with me.

Virtually none of this information has been found in written form or on the world wide web. It has mostly come from people's memories, with additional material gleaned from newspaper cuttings, magazine articles, minutes of meetings and personal collections of papers and documents.

Sadly, I missed meeting some of the earliest pioneers who passed away before I started the project but I was fortunate in meeting people who remembered them well and who had treasured memories, photographs and artefacts of the times they spent together.

I am especially indebted to Brian Lalor and would like to thank him and acknowledge his continued support and enthusiasm. Without access to his ceramic collection, archival material and prodigious memory, this book would have been a far less ambitious undertaking.

I am also grateful to Etain Hickey, Jim O'Donnell, Mary Jordan and Alannah Hopkin for sharing their thoughts and experience with me, about life in West Cork from the 1960-1990s.

Bibliography

Caprani, M.V. (1981) "The Fabric of Irishness" in *Ireland of the Welcomes*, Vol 30, January

Carroll, M. J. (1996) *A Bay of Destiny: A History of Bantry Bay and Bantry*, Bantry: Bantry Design Studios

Kiberd, D. (2001) *Irish Classics*, London: Granta Books

Read, H. (1974) *Education Through Art*, London: Random House

Maynard, B. *Modern Basketry From the Start*: HB 1973 Scribner

Carson, R. (1962) *Silent Spring*, Boston: Houghton Mifflin

Seymour, J. (1970) *Self-Sufficiency*, London: Faber & Faber

Mitchell Geraldine (1997) *Deeds Not Words The Life And Work of Muriel Gahan*, Dublin: Town House

Lalor Brian (1990) *West of West*, Dingle Co. Kerry: Brandon Book Publishers Ltd.

Peter Somerville Large (2000) *Irish Voices an Informal History 1916-1966*: London: Pimlico

The European Agricultural
Fund
for Rural Development:
Europe Investing in Rural
Areas.

An Roinn Gnóthaí Pobail,
Comhionannais agus Gaeltachta
Department of Community, Equality
and Gaeltacht Affairs

West Cork Development Partnership